THEODORE WADDELL

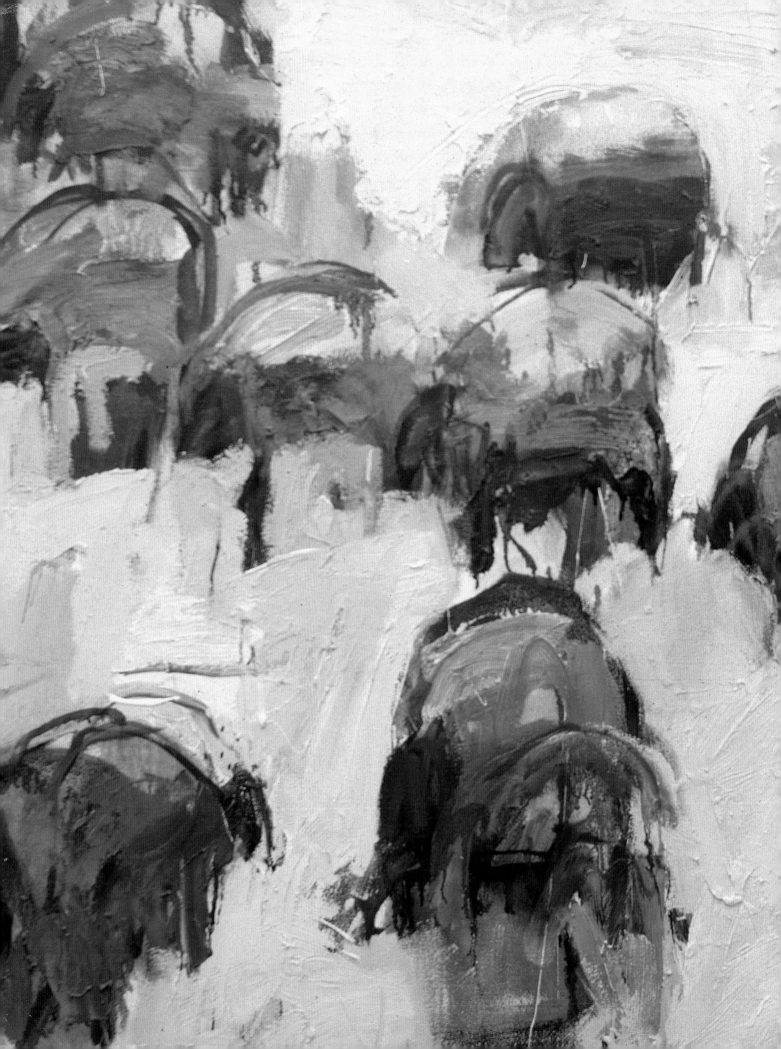

THEODORE WADDELL

INTO THE HORIZON
PAINTINGS AND SCULPTURE, 1960–2000

EXHIBITION CURATED BY BEN MITCHELL

INTRODUCTION BY PETER H. HASSRICK
ESSAYS BY TERRY MELTON, KIRK ROBERTSON, AND BEN MITCHELL

YELLOWSTONE ART MUSEUM
BILLINGS, MONTANA

IN ASSOCIATION WITH THE UNIVERSITY OF WASHINGTON PRESS
SEATTLE AND LONDON

Published on the occasion of the exhibition *Theodore Waddell: A Retrospective, 1960–2000.*

Exhibition Itinerary
Yellowstone Art Museum, Billings, Montana, November 18, 2000–February 11, 2001
Plains Art Museum, Fargo, North Dakota, March 15–May 20, 2001
Polk Museum of Art, Lakeland, Florida, June 9–August 12, 2001
University of Montana Museum of Fine Arts, Missoula, Montana, January 15–March 29, 2002

Designed and typeset by Phil Kovacevich and George Lugg

Edited by Sigrid Asmus

Printed by ArtCraft Printers, Billings, Montana

Front cover and Title page: *Basin Sheep #2* (1991); oil on canvas, 64 x 60 in. Collection of the artist. (detail)

Back cover: *Montana* (2000); oil on canvas, 120 x 216 in. Collection of the artist. (detail)

Photographer credits: Dedication page, pages 49, 50, 51 (top), 52 (top), 55, 57 (top) and 64, Phil Bell; page 30, Richard Carafelli; page 62, Fred Longan; page 48, Larry Meyer; p.52, Lyle Peterzell. All other photographs are by the artist unless otherwise noted.

ISBN 0-295-98043-5

Distributed by
University of Washington Press
P.O. Box 50096
Seattle, Washington 98145-5096

CONTENTS

In memory of my Dad.
I think he would have been pleased.

ACKNOWLEDGMENTS

This publication, and the retrospective exhibition of Theodore Waddell's marvelous paintings and sculpture that it celebrates, involved the time and generous efforts of many individuals. Our thanks go first to Ted Waddell, who has given so freely of his time and resources to the exhibition and this book. The Yellowstone Art Museum is honored and proud to have been able to organize the exhibition and this publication.

In addition to surveying over forty years of Ted Waddell's art, this book also offers insight into his work from four wonderful writers: Peter Hassrick, professor of American Western Art and director of the Charles M. Russell Center in Western History at the University of Oklahoma; Terry Melton, an artist and the founding director of the Yellowstone Art Museum; the poet and critic Kirk Robertson, the editor of *neon, Artcetera* from the Nevada Arts Council; and the museum's senior curator, Ben Mitchell, who also curated the exhibition and managed the production of this book. These writers have contributed enormously to our understanding of Ted Waddell's art.

Many Yellowstone Art Museum staff members also played vital roles in seeing the exhibition and catalogue from its conception to reality. Mark Zimmerer, preparator, designed the beautiful exhibition installation and, with registrar Nancy Wheeler, undertook the many details involved with organizing the traveling exhibition. Julia Murphy, the museum's development director, worked closely with the artist seeking underwriting for the project—an enormous task. Cheryl Anderson, Diane Cameron, Kim Albright, Jacob Anderson, Kristi Clayton, and Jet Holoubek all contributed to the success of this project. In addition, several former staff members helped begin this work, including former director Marianne Lorenz, who first conceived the exhibition, and Magi Malone and Robbie DeBuff, who helped bring together the initial registration and curatorial details. We also extend our appreciation to colleagues at the other museums sharing this exhibition: Mark Ryan, registrar, the Plains Art Museum, Fargo, North Dakota; Daniel E. Stetson, executive director and Todd Behrens, assistant curator/registrar, the Polk Museum of Art, Lakeland, Florida; and Maggie Mudd, director, the University of Montana's Museum of Fine Arts in Missoula.

We owe a special thanks to the production team in Seattle who made this volume possible. Phil Kovacevich shared the book's project management and is responsible for the handsome design, along with George Lugg, assistant at Kovacevich Design, while Sigrid Asmus managed the book's editorial aspects. Working together with museum staff, this team did an extraordinary job. Our thanks also to

Pat Soden, director of the University of Washington Press, who was supportive and enthusiastic about distributing the book.

No exhibition is possible without those who lend their work to make it happen. We are grateful for their generosity and willingness to allow their works by Ted Waddell to travel for over two years.

Finally, we are fortunate to list below all those individuals, galleries, and businesses that so generously supported the exhibition and publication. We are grateful for their support. It has been a great pleasure for all of us to work together to present the full range of Theodore Waddell's vision.

GARELD F. KRIEG, CHAIRMAN
YELLOWSTONE ART MUSEUM BOARD OF TRUSTEES

The museum, publisher, and artist wish to acknowledge the following generous contributions to the production of this volume:

John W. and Carol L. H. Green
The Yellowstone Art Museum Associates

William W. Bliss
Susan Duval Gallery, Ketchum, Idaho;
 Seattle, Washington
Friesen Gallery, Ketchum, Idaho; Seattle,
 Washington
Jill and Daniel Gustafson
Martin-Harris Gallery, Jackson, Wyoming
Munson Gallery, Santa Fe, New Mexico
James and Carla O'Rorke
Laura Russo Gallery, Portland, Oregon
James and Christine Scott
Thomas M. and Betty C. Scott
Bernice Steinbaum Gallery, Miami, Florida

An anonymous donor
Jerald and Esther Bovino
Frank and Sue Countner
Eleanor and Dr. William Goodall
Jack and Susan Heyneman
Neltje
Mr. and Mrs. Donn Roberts
Joe M. Serpa
Gary and Barbara Sorensen
Stremmel Gallery, Reno, Nevada
Mr. and Mrs. Ralph O. Wallerstein

Tercera Gallery, San Francisco, California
Bernie Rose
Margo Piscevich
Senia Hart

LENDERS TO THE EXHIBITION
William W. Bliss
Lynn Campion
Jack and Sally Dern
Donna Forbes
Les and Peggy Frank
Eleanor and Dr. William Goodall
John W. and Carol L. H. Green
John Heyneman
Brian Peterson
Shanna Shelby
Janelle Stephens
Arin Waddell
Theodore Waddell
Betty Whiting

The exhibition *Theodore Waddell: A Retrospective,
 1960–2000* was generously underwritten by:

Holiday Stationstores
The Pollard Hotel
An anonymous donor

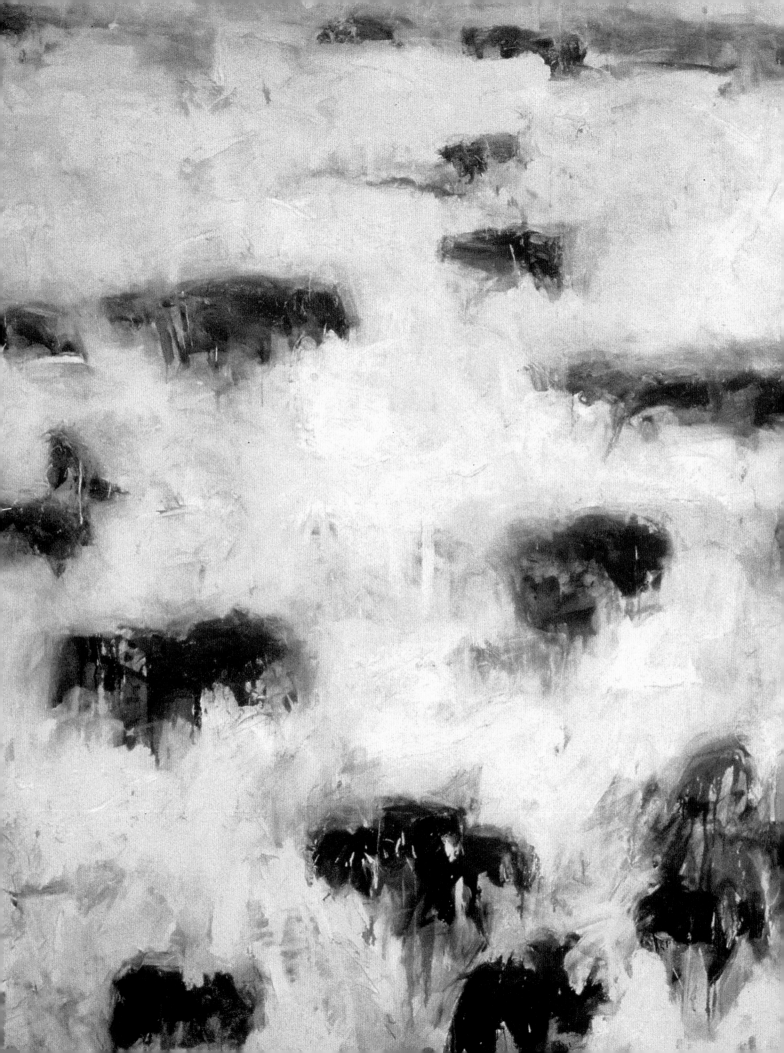

INTRODUCTION

PETER H. HASSRICK

I stood in a museum gallery the other day, listening to visitors as they passed by a big, lusciously painted canvas by Ted Waddell. The remarks that I remember were given in short, spirited vocalizations, and the vocabulary varied as they described their reactions to the work before them. One called it, without the slightest hint of equivocation, "messy," while another, in a more reflective tone, used the word "enchanting." And yet a third was heard to say, with something of a relieved expression, "Hey, yes, it is . . . it's a horse." Then they moved on to the next artwork on the wall, and I noticed, as they passed me, that they did so with a smile. They had been engaged. They had responded to the artist's method, to his mood, and to his subject—the last of which is at first blush sometimes rather less evident than the other two. What I came to realize, as I watched average people visit this painting, was that they, like me, seemed to respond first to the process involved, second to the spirit of the piece, and then to the theme.

Waddell's pieces are both physical and pictorial acts. They are quite literally about the process of painting, and it is the process of their creation that is revealed so boldly to viewers, participants really, that they find it impossible to resist being involved in the kinetic force of the art. Waddell is inclined to paint subject pictures, pictures that show us fascinating elements of his world. But for every iota of narrative that is evident, there are as well enormous plentitudes of workmanship, or what might better be called affectionate labor. His paintings are vigorously brushed, saturated with color, and richly indulgent in the exploitation of pigment. They are works (he calls them "combinations of marks") that capture the appearance of forms . . . forms that are, more often than not, submerged in space and absorbed by the place of their being.

The artist, like his subjects, thrives on a relatively secluded existence. His geography, a Montana ranch and a home near Sun Valley, is one of isolation. Yet it is isolation tempered with an extraordinary personal drive to engage friends, colleagues, and his audience in his special world. In his efforts to attract and keep us there, Waddell produces works that are overtly greedy for our attention. We find it nearly impossible to resist them, and we are consumed by the vigor with which his themes are presented. His life as a rancher and his vocation as a painter, sculptor, and printmaker are ineluctably wed in his art. Each puts the other into perspective and allows us access—at least partially although always enjoyably—to a creative fete of fascinating and considerable proportion. While we see these works as spontaneous, vital, and exuberant, we also feel them with other senses. They are as thick with metaphorical

left: *Alzada Angus* (1992); oil on canvas, 72 x 144 in.
Yellowstone Art Museum Permanent Collection, Museum purchase funded by Miriam Sample. (detail)

associations to animals, seasons, and sacred places as they are with hues and pigments. The moments of the artist's life, like the textures that have virtually lived at the end of his brushes, are expressed not just as surface modulations but as ebullient passages of affection. His bond between life and art is wide enough to hold a place for those of us who reside outside his immediate world but who are intertwined, like just so many of his brush strokes, with his message.

Montana has found itself featured in the work of any number of artists who have firmly connected the place where they live with their artistic expressions, their physical lives, and their spiritual essence. Charles Russell was one of the most prescient of those forces, as was Isabelle Johnson. Both have stood as serious elements in the artistic landscape, helping Waddell define himself as an artist, and he openly and proudly acknowledges them for their artistic mentoring and for their bright, wholesome view of the place that art holds in our lives. The Yellowstone Art Museum has a long tradition of honoring those like Russell and Johnson who have contributed so richly to Montana's art scene, explored the West through their work, and who have proven over time that their art and the place they revere are in fact nationally significant. With this retrospective exhibition of the work of Ted Waddell, the Yellowstone Art Museum once again stands at the forefront.

right: *Monet's Sheep* (1994); oil and encaustic on canvas, 78 x 120 in.
Collection of John W. and Carol L. H. Green. (detail)

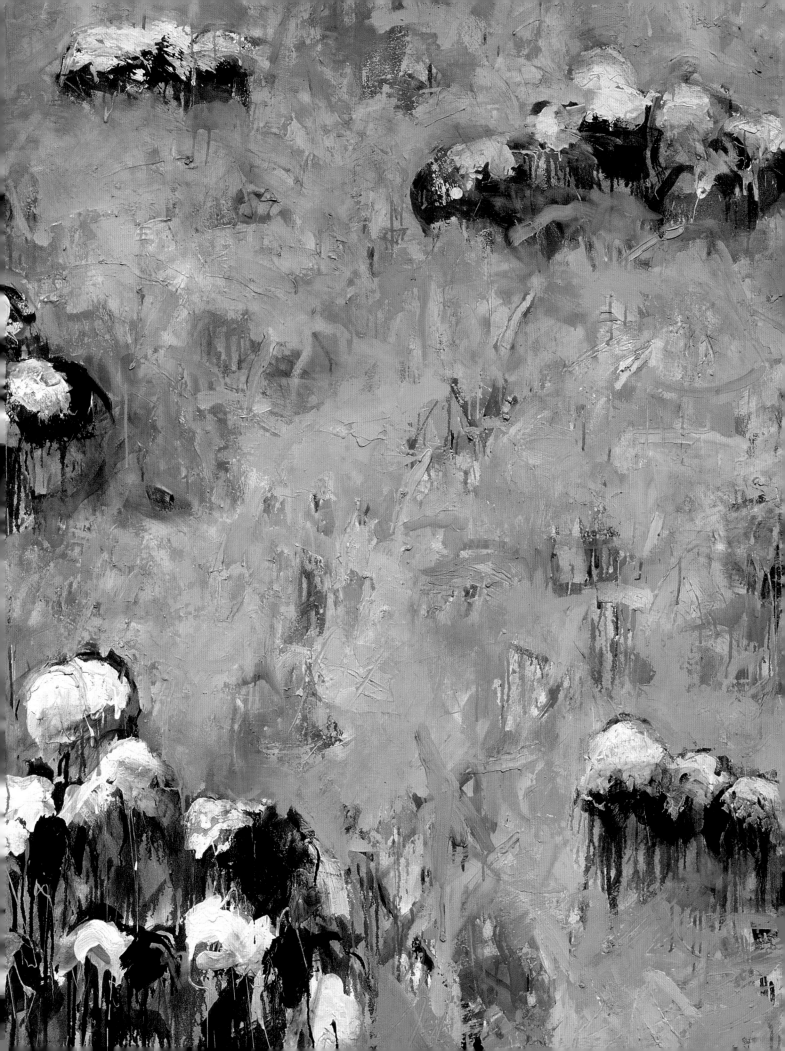

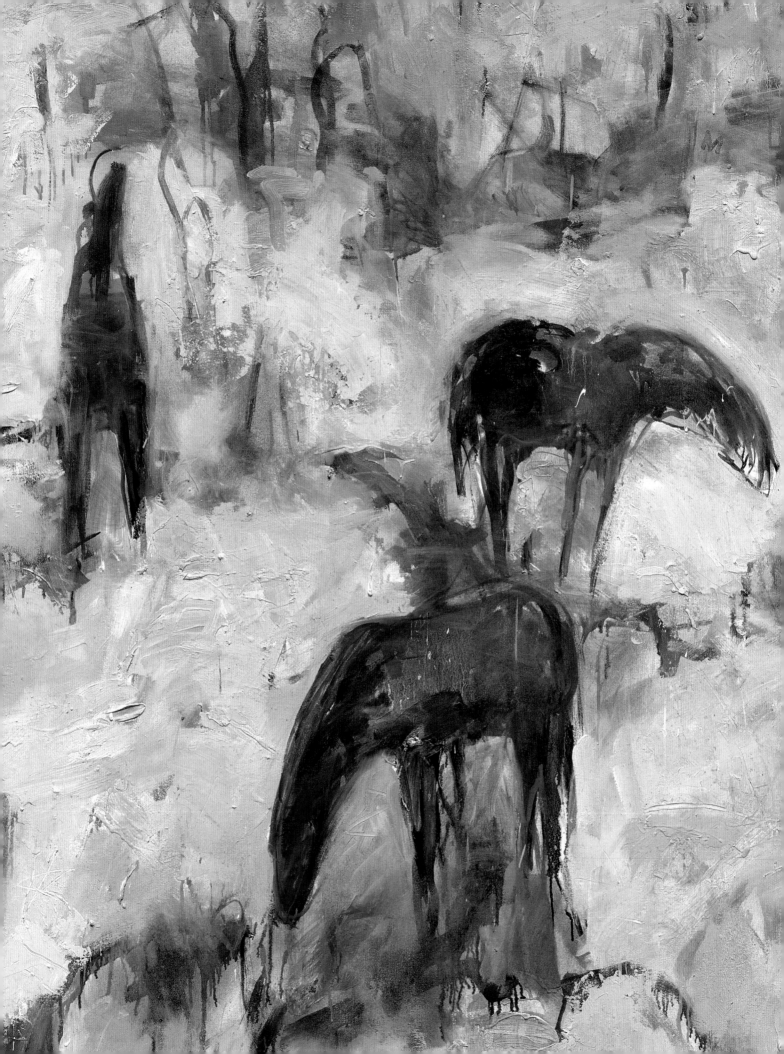

THE CHALLENGE OF SEEING

TERRY MELTON

> I cannot judge my work while I am doing it. I have to do as
> painters do, stand back and view it at a distance, but not too
> great a distance. How great? Guess.
>
> PASCAL

It was a Montana winter thirty-six years ago when Theodore Waddell and I first met. He had recently finished a brief stint at the Brooklyn Museum Art School and before that, and after, worked to complete an undergraduate degree at Eastern Montana College in Billings. I had just been hired for my first administrative job at the fledging Yellowstone County Art Center (now Museum) as its first director. And 1965 was a watershed year for visual arts facilities in Montana, as the state began to climb out of the deep boot-heel imprints of Charles M. Russell and Frederic Remington. The Yellowstone was the first all-arts forum in the state; by 1975 there would be nine such facilities spread across this sprawling swath of mountains and prairie. And eventually Ted would show his work in most of these new art spaces.

Ted Waddell and Montana have always danced well together. I cannot picture him having another partner in his over sixty-year waltz with this extraordinary piece of North American land. It attracts poetry, prose, and painting like a magnet pulling through iron filings. It is a home, it is seasons of great change, it is snow, wind, green and buckskin tan, sky and heart. And it has been Theodore Waddell's passion, his animation.

Ted Waddell grew up in Laurel, Montana, just to the west of Billings, a one- or two-blink-of-the-eye town if you didn't stop for coffee on the way to Bozeman. Situated along the Yellowstone River, the broad valley is home to the Crow Tribe, modest industry, and ranchers. Dry-land wheat farming spills out to the north above the Yellowstone rimrock that accompanies great stretches of ranch land. And there are still glimpses of prairie—now haunted by bison ghosts and memories of the Native people who depended upon them. There are substantial mountains to the south and further to the west. It's a country made for romantics but tough pickings for sentimentalists. Many of the writers and painters who try to match wits with the vastness are overwhelmed with it all. At a distance or close-up, this land burrows its way into one's Id. Ted Waddell's wrestling with it is aimed at a close horizon. He chooses to tell us a little more by telling us a little less.

left: *Chinook Horses* (1991); oil on canvas, 78 x 90 in. Collection of the artist. (detail)

In 1965–66 Ted was finishing his work at the college in Billings. He had an old neighborhood grocery storefront for a studio that became, sort of, the 34th Street Gallery for a small group of us who did not dote on copying C. M. Russell pictures. We showed our work irregularly and precious few people irregularly came to see it. About a year later Ted packed up what he had and headed for Wayne State University in Detroit, where he finished a Master of Fine Arts degree in 1968. That same year he took a faculty position in the Department of Art at the University of Montana, in Missoula, remaining there until 1976. His emphasis at Wayne State had been sculpture and lithography. In Missoula he concentrated on sculpture, and primarily on minimalist stainless and painted steel work, which a number of artists were doing at the time, all of them feeling the reverberations of the modern benchmarks set by David Smith and then Donald Judd. Ted's work was superb, but not unique. And it had little to do with the influences that would later surface in his paintings.

We seldom quite know where our learning comes from; never quite know how it comes. There are identifiable turning points, of course, but those recognitions are rare compared to the osmosis-absorbing we obtain without a conscious awareness.

During Ted's art studies in the early 1960s in Billings there was a remarkable painter-teacher also working there, Isabelle Johnson. It's my guess that Ted was not truly aware of her influence at the time. But by the late 1970s, Isabelle (nearly everyone called her Isabelle) and her painting and drawing would

become important touchstones for his artistry as he put aside his metal sculpture in favor of the splendid paintings we know today and have become so taken with these last twenty years. My own first encounter with his new work was in the *Second Western States Exhibition*, which showed also as the *38th Corcoran Biennial* in Washington, D.C. The paintings were extraordinary and the show markedly enhanced his public career as a painter. His pictures were dark and brooding, and inhabited by Black Angus cattle within a close Montana horizon. Powerful stuff.

ISABELLE JOHNSON (1901–1992), *Calves, Winter* (ca. 1950); oil on canvas board, 16 x 20 in. Yellowstone Art Museum Permanent Collection, Estate of Isabelle Johnson.

Isabelle Johnson was a rancher and a painter from Absarokee, Montana. To the occasional consternation of two sisters and a brother on the Johnson home ranch, Isabelle ranged away for studies at the University of Montana, Columbia University, the Otis Art Institute, and the Skowhegan School of Painting and Sculpture. And she was teaching at Eastern Montana College during Ted's first tenure there. Her painting influences were solid and terribly important to the young artists who did not follow the more tradi-

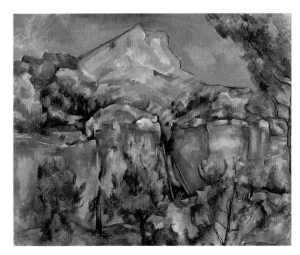

PAUL CÉZANNE (1839–1906), *Mont Sainte-Victoire Seen from the Bibemus Quarry* (1897); oil on canvas. 25⅛ x 31½ in.
The Baltimore Museum of Art: The Cone Collection, formed by Dr. Claribel Cone and Miss Etta Cone of Baltimore, Maryland. BMA 1950.196

tional paths cut earlier by western pictorialists. Despite her art studies, she remained "Montana" through and through.

Isabelle was an unswerving devotee of Paul Cézanne and his painting structures. I think she measured everything forward and backward from Cézanne. She took his forthright painterliness as gospel and applied it to the images surrounding the Johnson ranch in Absarokee: sheep, cattle, cottonwoods, willows, grass, mountains, and the magnificent Stillwater River. I believe her solid stodginess, like Cézanne's, prompted latent learnings that brought forward many of the images we have come to know in the paintings of Theodore Waddell. Not copies, thank you, but rather essences—contemporary visions of the landscape

ISABELLE JOHNSON (1901–1992), *The Chinook After a Hard Winter* (1981); watercolor on paper, 25½ x 19 in.
Yellowstone Art Museum Permanent Collection, Gift of Security Bank, Billings, Montana, in honor of Oliver M. Jorgenson.

Longhorn Drawing #3 (1985); oil on paper, 19 x 26 in.
Collection of the artist.

and its critters mixed with the breakthrough attitudes turning up in modern painting. It's not simply making pictures, it is the challenge of seeing possibilities and pushing them for all they are worth. And I emphasize *seeing,* not merely looking, and never allowing one's work to be overtaken by the wiles of a facile hand or a false emotion. As Jean Cocteau once mused, "Emotion resulting from a work of art is only of value when it is not obtained by sentimental blackmail." Solid painting, solid Cézanne, solid Isabelle, solid Waddell.

Another Montana painter, twenty years senior to Waddell, has also had an impact on his work: Bill Stockton, from Grassrange, Montana. Stockton is an uncommon painter, a no-nonsense maker of marks, and an incomparable curmudgeon. Following World War II, Bill studied at the Minneapolis School of Art and then the École de la Grande Chaumière in Paris. He returned to the home ranch some ninety-five miles north of Billings and has spent his life ranching, raising sheep, cursing coyotes, hating the "art game," and picking fights with every thunderstorm that dares show itself on the horizon. And when there was time, and there was always time, he has made pictures that reflect *his* Montana, with echoes of the structures of his abstract expressionist roots of the 1940s and '50s. He uses his free-flowing marks to talk about the prairie and its seasons. Stockton's work delivers tight and disciplined heroics. His talents and gutsy straightforwardness have been other pieces of learning for Ted Waddell, who has absorbed much of the Stockton directness. And winter, for both, is the most princely time.

BILL STOCKTON, *Another View of Chinese Mountain* (1991); livestock marker and pencil on paper, 30 x 22 in.
Yellowstone Art Museum Permanent Collection, Museum purchase funded by Miriam Sample.

In the 1970s, the center for visual aimlessness was in New York City (where it still seems to be). That decade saw uncommon growth in all the various arts, largely due to an infusion of money and activism—through federal, regional, and state arts agencies. Because of all the new money available, battle lines were drawn by organizations, promoters, and individual artists. The toughest battle line was, of course, the Hudson River. Beyond that line and to the west was the remainder of the United States, "the region." I recall the word "regional" being tossed about, nay hurled, as an epithet used to dismiss most all of the stuff that did not match up to New York City polemics. A sort of doctrine of snubbing then came into play that affected forums for artists outside Manhattan. The most pointed snub was to refer to an artist's work as "regional," as though that were a sort of genetic affliction. Curious enough, to be sure, but even more

curious now, seeing that the decade gave us the beginnings of the "victim" art many of us have come to loathe. (Not the stories; they deserve to be told.) The loathing is due to the flood of undisciplined story-tellings. Such freedom is only a wink away from anarchy. And, as Robert Frost wrote, "freedom is running well in harness." Poor storytellers miss the grandness—in words or paint.

Whether abstract or pictorial, most challenging and informative painting has had its roots in a region. Even New York had its own regional qualities, agreed-to or not by the critics. So did the Bay Area, as well as the Pacific Northwest in the 1950s. Before that there were the Midwest regionalists of the 1920s and '30s and the turn-of-the-century pictorial western genre painters, led most notably by Russell and Remington. Pick some favorites: Rembrandt to Cézanne, Daumier to the Ashcan School, Catlin to Homer, Guston to Diebenkorn . . . all products of a regional impetus.

We have witnessed the end of the International Style, watched it buckling under its own weight. We have begun to re-understand the great strength of a regional source, one that can proclaim a wider understanding outside regions. International should mean a comprehension and celebration of our differences, adding up to a sharper discernment of the whole. We have begun to re-examine our surroundings not only for what they are, but what they might be. The architect Alvar Alto, for example, who, when asked what a city should be like, replied, "You should not be able to go from home to work without passing through a forest." We could embrace that and take it even further: not go through a day without seeing a painting of merit or digesting a poem of enlightenment.

Angus #108 (1983); oil on canvas, 66 x 90 in.
Collection of the artist.

The regional attitudes and the close horizons of Waddell's painting push us to an awareness of a harmony we might miss if we assume the world begins elsewhere. He has wrestled with close observation continuously since 1976. In those years and to date his home has been ranch land, cattle, horses. And it is usually the winter months that allow time for quiet considerations, and ample time to absorb them and paint what is in the mind's eye of memories. Contrasts are greater then and so are similarities, those contradictions that make painters, painters. One sees these qualities in the work of J. H. Sharp's winter landscapes and in John Henry Twatchtman's, in Isabelle Johnson's work, in Stockton's, and in Waddell's.

The creatures in Waddell's paintings are, in the main, cattle and horses. The cattle coalesce in the landscape; the horses (as horses will) seem to argue. They both own their own territory but in different ways. The cattle plant their feet, the horses fly with theirs. And Ted's horses have the power to recall,

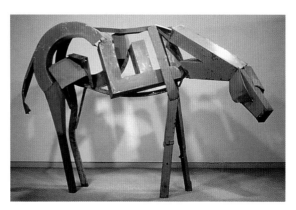

DEBORAH BUTTERFIELD, *Ferdinand* (1990); found steel,
77 x 116 x 33 in.
Yellowstone Art Museum Permanent Collection,
Gift of an anonymous donor.

with those of Rosa Bonheur, the fanciful style of Elie Nadelman, the weight of those of Deborah Butterfield, the force of life in those of Marino Marini. All different, of course, but they all proclaim "horse." And we cannot forget that Ted's paintings also say "paint." Metaphor for prairie and creatures it may be, yet we remain both delighted with and curious about the possibilities of paint telling us such stories.

And what paint can do is important particularly to modern painters. We became truly aware of paint as paint when we saw the work of the unsung and now sung-to-the-art-heavens Vincent van Gogh. The metaphor in his images was not lost in the depth of his paint-tube squeezings. It simply took on an added dimension if not an added life. Many modern painters know the romance of paint on surfaces. It is sculpture, cake icing, dimensional map cartography, memories of our childhood's stirrings of mud pies. There's also a splendid feeling of power when the lids are pried off quart and gallon cans of primary and secondary colors. And black. And the white, that great extender of lightness and brightness. Ted's work capitalizes on the headiness of the sheer amplitude of the additional surface. These rich external squiggles both compliment and contradict the stories being told, giving us a bonus of exaltation. Perhaps there is a free lunch after all.

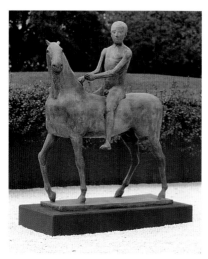

MARINO MARINI (1901–1980), *The Pilgrim (Il Pellegrino)* (1939); bronze, 68⅛ x 48¾ x 16½ in. Museum of Fine Arts, Houston, Texas; Gift of the Hobby Foundation.

If luck were occasionally with us we might alternate between Alto's forest and Waddell's paintings. Minus that opportunity, this retrospective exhibition and its catalogue will be a not-indecent substitute. The creatures and the landscapes of Ted's paintings, drawings, and sculpture add to the mountain–prairie tellings of Chief Joseph, A. B. Guthrie, Dorothy Johnson, Ivan Doig, James Welch, William Kitteredge, Richard Hugo, C. M. Russell, Joseph Henry Sharp, Rudy Autio, Dana Boussard, James Poor, Isabelle Johnson, Bill Stockton. And of course others. One knows that the big sky of Montana—and its light—cause more than just heart-fluttering horizons; they bring about the grand illumination of the creatures in front of the prairie, and the prairie in front of the creatures. Waddell's world is a close horizon, sometimes of grand scale, sometimes small, but for sure, close. Then there's the distribution of feeling between painting and ranching, often a bit of a blur for Ted. And that is as it should be. It pushes us to attempt to figure out, if we desire to do so, where one leaves off and the other begins. In painting, his work deals poignantly with the seasons, and, most strongly, with winter. The ranch leaves precious little time for painting, so the summer work, beyond the stock, is chucked into the

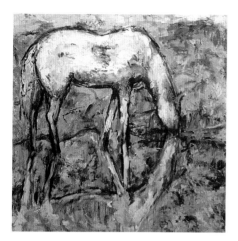

Lynn's Narcissus (1997); oil and encaustic on canvas, 72 x 72 in. Collection of Lynn Campion.

memory lofts. As the paintings tell us new stories they help explain some often-overlooked truths, of the kind Cézanne called "ma petite sensation." It's not some grand scheme that can't be understood unless you know the fragments making up the composite view. If those moments of sensation are overlooked or ignored, then the grand scheme will always remain elusive.

Perhaps Goethe put it best: "The true artist declares himself by leaving out a lot. The artist alone sees spirits. But after he has told of their appearing to him, everybody sees them." Once one sees them the inquiry expands, because well-placed marks give us the metaphor for understanding. And if the artist is also fortunate in imagery, one also comes to know how to celebrate, without ever forgetting the paint in which the spirit lives.

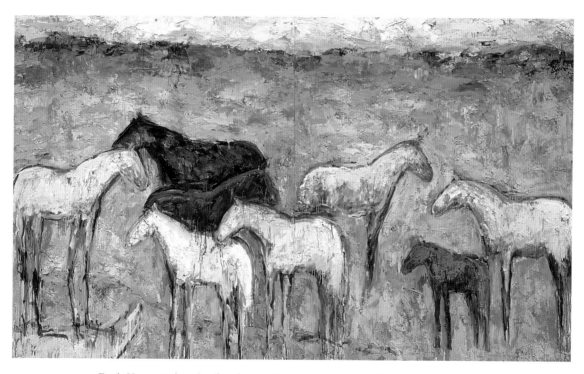

Ennis Horses #6 (1998); oil and encaustic on canvas, 88 x 114 in. Collection of the artist.

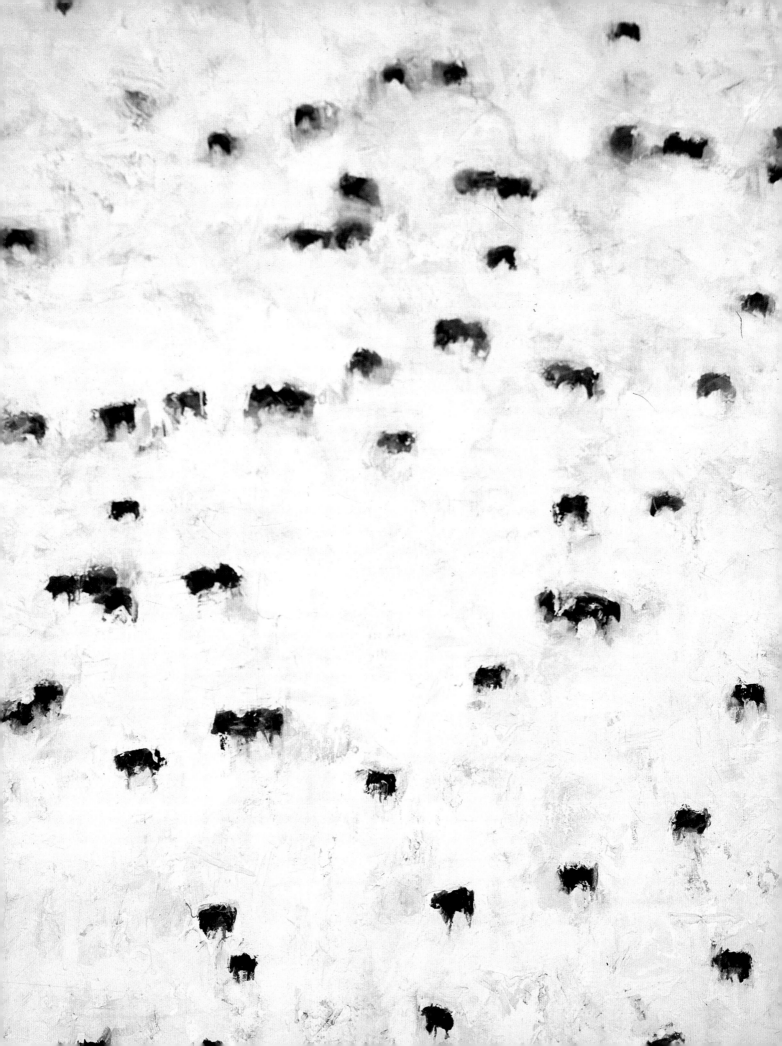

SEIZING THE EPHEMERAL

KIRK ROBERTSON

> While art most often imitates life, life also has a tendency to
> copy art when that art is sufficiently enshrouded in myth.
>
> PETER HASSRICK

> Western art is the result of history overwhelming your brain.
> The power of the myth . . . has been planted firmly in our
> minds. . . . The transition from image to myth, reality to
> fiction is so very short that maybe it occurred immediately.
>
> THEODORE WADDELL

> Things aren't what they used to be; and what's worse, they
> never were.
>
> JOHN SZARKOWSKI

Sometime during the nineteenth century—thanks in large part to the work of artists like Albert Bierstadt, Thomas Cole, and Carleton Watkins—natural features of the western landscape became the icons, the foundations of a mythological national identity that was quickly codified into a story told and re-told, and that became the epic fantasy of the American West. In this church of the imagination, it was the artists who were charged with the role of priests and who created the altarpieces—paintings— to guide and inform us on our ever-westering trek across the plains of allegory. These were not so much history paintings, where the story had already happened, but rather their country cousins of the genre kind, presenting landscapes that were waiting for something to happen, for the story to unfold. As it very quickly did.

The journey from Lewis and Clark to Charles Russell and John Wayne, and from Timothy O'Sullivan to Ansel Adams and the Sierra Club, was covered in barely more than one lifetime. Those landscapes— the heaven of Yosemite, the hell of Yellowstone, and everything in between—have become destination- resort national parklands, ringed with enclaves of upper middle class homes. Inside these homes, the walls are decorated with scenic views, with the descendants of those nineteenth-century works—

left: *Motherwell's Angus* (1994); oil and encaustic on canvas, 72 x 72 in. (detail)
Denver Art Museum Collection; Gift of Barbara J. and James R. Hartley, 1999.84.
© artwork by Theodore Waddell.

JOHN FERY (1859–1934), *Mt. Jackson, Glacier Park* (n.d.); oil on canvas, 71 x 44 in.
Yellowstone Art Museum Permanent Collection.

sofa-sized Remington knockoffs and Ansel Adams posters of sublime grandeur. The portrayals of the mythology of the Old West have become the preferred furnishings of the New West.

On the drive from Fallon, Nevada, to Waddell's place near Manhattan, Montana, in the Gallatin River Valley northwest of Bozeman, movement and change are provided automatically—all you have to do is look through the windshield. In doing so, it is easy to see that the "look" of the American west is changing. It is beginning—and well past beginning in many areas—to look pretty much the same everywhere. In what some have called a "geography of nowhere," you see the same strip malls, the same enclaves of Costcos and Home Depots from Reno to Boise and Bozeman. For miles and miles along the Salmon River it seems as if the local economy is based entirely on making "real" log homes. You see the same suburban sprawl of similar looking homes—ranchettes—in Ketchum, Elko, or along the Gallatin. Architecturally indistinguishable, they all have the same preferred colors of the moment: light battleship gray and adobe brown, the avocado and almond of the 1990s. The gateways to these ranchettes are formed from huge logs; hoisted aloft to create massive triumphal entries, they are emblazoned with the names of the lucky new ranchette owner, or with the gerund-enhanced names of bulldozed-out trees—*Whispering Aspen, Trembling Pines.* The conventional western folklore of *the bigger the hat, the smaller the ranch* is here rephrased as *the smaller the ranchette, the bigger the arc de triomphe.* In the environment of this New West, the idea of landscape ornaments just about everything from beer cans and cocktail napkins to the hyperbolic descriptions of idyllic "view sheds" promulgated by real estate developers. You can see another interesting aspect of the rephrasing of the West in the syntactical shift from noun to adjective, from cowboy to cowboy pizza, from West to western.

Transportation (trains, automobiles, planes) and communication media (television, e-mail, cell phones) have altered our relationship with landscape, changed the way we see it. Wilderness has become a "wilderness experience." Our contact point with what we call the landscape has also been transformed: now we see it through our car windows or computer screens. Television and computers, not painting, are our windows on the world. We are in our element when we are out of the elements, in a place where history is a channel, where Larry McMurtry's serialized Westerns or our own "individual" virtual landscapes are but a remote- or mouse-click away.

Perhaps part of the growing fascination with the Internet is simply a manifestation of our desire for illusion, for the ability to transport ourselves to another landscape. This idea of transporting ourselves, translating our realities, has been a common thread in the imagination of the American West from the

railroads of the nineteenth century to the so-called info superhighways of today. Similarly, the landscape imaginings of Theodore Waddell—his re-visioning of the past as present, his translation and reinvigoration of the tradition by making it new—give us a fresh window on familiar, yet evolving, terrain. A new way of seeing where we are.

A place belongs . . . to whoever . . . remembers it most
obsessively [and] . . . renders it so radically that he remakes
it in his own image.

JOAN DIDION

de Kooning provided a language you could write your own
sentences with.

AL HELD

What I try to do . . . is alter perception . . . to move from
what I know to what I don't.

THEODORE WADDELL

All cultures construct and convey visions of nature, but the idea of landscape, a description of nature via a picture within a frame, is in large part one peculiar to the western European tradition and its heirs—the art of the American West. Landscape is an unfashionable thing to think about these days, something a lot of contemporary art tends to shelve away with countless recast Russell bronzes and the efforts of legions of wanna-be Sunday painters who continue to re-express as fact what was from the start a mythological West. But for Theodore Waddell, landscape is the language of life and paint; it is the syntax he uses to translate the idea of landscape into new information, the Old West into the New.

Waddell's paintings take specific landscapes as their points of departure. It is the prompting of reality that sparks the creation of a mood. Yet while a painting may be ignited by something "out there" in the real world, the resulting translation is a record of the artist's exploration of, and meditation upon, a situation that interests him. He speaks often of the way shadows vary with times of the day, of the four seasons, of the differences in color—all elements that imply a certain awareness of things cyclical, hinting at the ways a jazz solo returns to pick up the melody. This thing that excites him becomes its content. Starting in the here and now, he improvises toward the infinite.

The paintings are an attempt to speak that language more precisely, to enable the artist to understand its syntax more fully than when he started. His rendering of the information, his translations of the space of a specific landscape, provide an alternative description of that space—as in the swirling pas-

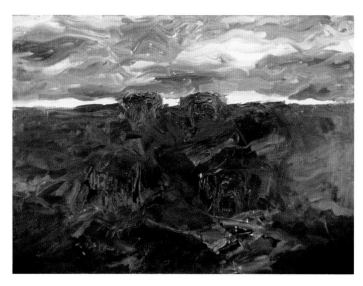

Angus Sunrise #6 (1986); oil on canvas, 36 x 50 in. Collection of the artist.

tures of *Angus Sunrise #6* (1986) or in the evocation of densely stacked critters in *Angus #78* (1984). Abstract Expressionism took the earlier premise of painting—as creating an illusion of space—and by removing its objective correlative references pushed the canvas toward becoming an object in and of itself. Waddell's paintings, his translations of space, do exactly that, but they also take the object back toward illusion again. They are both a precarious balancing of this equation between object and illusion, and the antithesis of traditional western Remington–Russelesque single-point perspective.

Waddell's brand of abstraction blends the active, gestural ideas of Abstract Expressionism with an apposite accrual of reductive yet readable elements to create a kind of distillation, a stronger essence of the matter at hand. Similarly, in Piet Mondrian's work there is a series of paintings of trees in which the images progress from realism through abstraction to total nonobjectivity. The processes of Mondrian and Waddell are related in that with both artists the use of abstraction becomes a type of imagery itself; one in which—in works by Waddell such as *Angus #116* (1984) (page 93) and *Angus Drawing #371* (1986)—the very accumulation of the reductive elements begins to reach toward other colors, values, and shapes, begins to render other realities.

There is no such thing as a good painting about nothing.

ADOLPH GOTTLIEB AND MARK ROTHKO

The artist's goal is not to faithfully reproduce [nature as] air,
water, rocks and trees . . . but to both take it in and convey it.

CASPAR DAVID FRIEDRICH

Because of this process, the paintings can be seen as a series of metaphors. We can speculate all we like about the content and/or meaning of these metaphors. But what matters, what really matters, is their impact on our nervous system when we see them, their impact on our perceptions, and the way we see them, just like the landscape "out there." To state the obvious, Waddell *loves* paint. He literally sees the landscape as colors, tubes of color—alizarin crimson, cerulean blue, yellow ochre. His work is a painted fiction, but not necessarily a straightforward narrative. The paintings simultaneously have the ability to be frighteningly stable—arising from specific, real places—Monida, Ennis, Two Dot—and

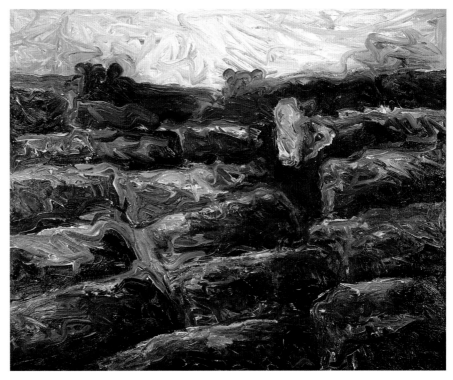

Angus #78 (1984); oil on canvas, 45 x 60 in. Collection of the artist.

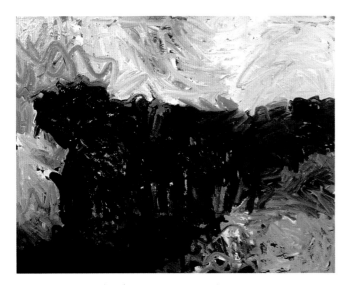

Angus #62 (1984); oil on canvas, 48 x 60 in. Collection of the artist.

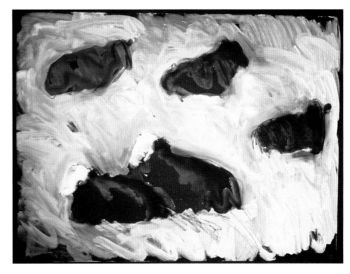

Angus Drawing #371 (1987); oil on paper, 22 x 30 in.
Collection of the artist.

totally unstable, mutable, capable of dissolving into nothing but a joyous concatenation of paint, as in *Alzada Angus* (1992) (page 113).

In work that is more representational, you can take apart the elements, contemplate the separate metaphorical references; but in Waddell's paintings, where he walks a constantly shifting line between depiction and abstraction, things melt and/or drip together. Marks and images, background and foreground coalesce and fuse, the canvas teems with energy, and there is a direct perceptual, physiological response to the paint itself. It's the same pleasurable, visceral jolt you get from the paintings of Francis Bacon and Willem de Kooning.

> The main problem is how to create with one's instinct
> something that one sees.
>
> FRANCIS BACON

> The artist accepts as real only that which he is in the process
> of creating . . . each stroke has to be a decision and is
> answered by a new question.
>
> HAROLD ROSENBERG

Waddell's earlier paintings—*Angus #66* (1982), *Angus #78* (1984), or the thickly impastoed *Angus #108* (1986) for example—contain stark animal shapes that emphasize form or convey those forms in the process of literally melding with the landscape through forceful and energetic brushwork such as can be seen in *Angus #65* (1983). But even then he wasn't interested in educating us as to what a cow looks like. He'd rather leave that to beginners who think that realistic rendering is the ultimate truth. Then as now, he is much more interested in suggesting a mood than re-modeling any kind of truth.

Later, his perspective grows more expansive, to include herds of animals grazing in a series of heavily impastoed pastures that vary by season. In *January Angus #4* (2000), the figure–ground relationship is dissolving, shoving everything into the foreground, blurring it and the background into a more-or-less seamless abstract-expressionist whole without a center, one that forever grounds the animals in the landscape.

In more recent work, such as the huge *Monida Angus* (1998–99) (page 129) and *Iris Creek Angus* (1999) (page 130), the Angus have become small, dark, floating objects that we take to be Angus because we know the artist's history and have begun to see the landscape through his eyes. Looking like the "floaters" that occur in one's vision, these are an effective inversion of Ezra Pound's well-known

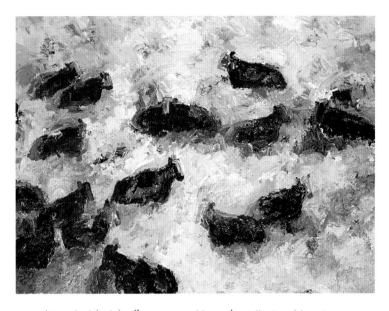

Angus #108 (1985); oil on canvas, 66 x 90 in. Collection of the artist.

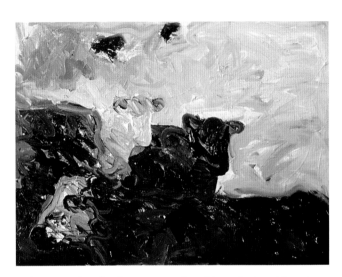

Angus #66 (1983); oil on canvas, 38 x 48 in. Collection of the artist.

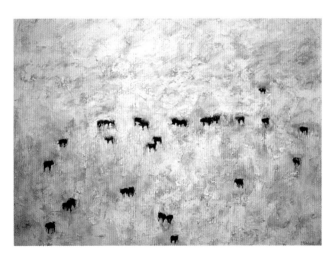

January Angus #4 (2000); oil and encaustic on canvas, 78 x 108 in.
Collection of the artist.

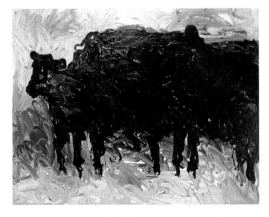

Angus #65 (1983); oil on canvas, 48 x 60 in.
Collection of the artist.

image of faces in the Paris Metro as "petals on a wet black bough." And while the Angus may have diminished in size, the sky is getting bigger, looming, reaching out and over you, drawing you into the paintings. In creating the possibility of being in the painting, in the landscape, these larger paintings invoke the all-over field paintings of Jackson Pollock. They give shape to something that is a pure abstraction, a landscape of the mind where ideas are more implied than described.

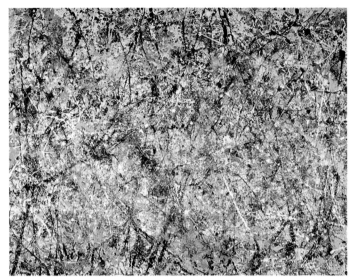

JACKSON POLLOCK (1912–1956), *Number 1, 1950 (Lavender Mist)* (1950); oil, enamel, and aluminum on canvas, 87 x 118 in. National Gallery of Art, Washington, D.C. Ailsa Mellon Bruce Fund.

This kind of working strategy operates as an "as-if" situation in which the artist works with his instinct to create something that only he hears or sees, that cannot be heard or seen until he has created it, that cannot be painted until he has painted it. It is a strategy that calls for a certain rapidity of response to transitory sensory perceptions—to seize the moment—that lends itself to working in series in order to rephrase the melody in other ways. As Francis Bacon put it, it is the ability to "grasp something that is constantly changing." And, lastly, it is analogous to the way Claude Monet used haystacks and the facade of the cathedral at Rouen to frame his meditations on light and surface, to capture the way atmospheric and climatic changes can alter the very appearance of structure—the moment alone becoming the subject of the painting. In paintings such as *Motherwell's Angus #6* (1996) (page 123) and *Monet's Sheep* (1994) (page 119), Waddell

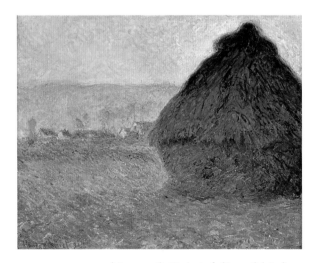

CLAUDE MONET (1840–1926), *Grainstack (Sunset)* (1891); oil on canvas, 28 ⅞ x 36 ½ in. Juliana Cheney Edwards Collection, Courtesy Museum of Fine Arts, Boston.

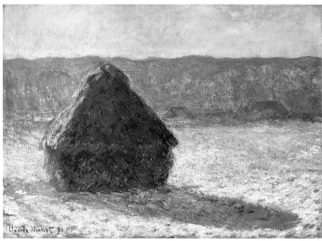

CLAUDE MONET (1840–1926), *Grainstack (Snow Effect)* (1891); oil on canvas, 25 ¾ x 36 ⅜ in. Gift of Misses Aimée and Rosamond Lamb in Memory of Mr. and Mrs. Horatio A. Lamb, Courtesy Museum of Fine Arts, Boston.

is expanding our definitions of what might be found in Montana landscapes by conjuring Angus as his own elegiac republic, and transmuting sheep into blossoms drifting in the pond.

Both Monet and Waddell are concerned with transforming appearance into image, with rendering the sensation produced by the landscape rather than the landscape itself. Neither artist is concerned with expressing a naturalistic reality; instead both wish to enable us to feel the emotive sense of that reality. If Impressionism later wandered off that rigorous trail and ended up in the pretty vacuousness of color field painting, then it is all the more interesting to find that Waddell has used some of the tenets of Abstract Expressionism not only to resuscitate Impressionism, but also to force us to deal with the fact that we are looking at both a painting *and* an object, both an abstraction *and* an illusion.

Such fantastic feathery scrawls of gauze-like vapor on this elysian ground.

HENRY DAVID THOREAU

There is an alchemy about oil paint that defies explanation.

THEODORE WADDELL

Light is the medium, the alchemy by which the landscape painter turns matter into spirit. Waddell's paintings are at once glimpses, snapshots, impressionistic moments, and extended meditations. Waddell likes jazz, if it is melody based, and clearly there are analogies to be made between his paintings and the idea of a solo in which the musician explores variations and improvisations on a theme before returning to and picking up the melody, albeit at a different place than where he left it. The difference is that in music you have the moment, yet must remember the past and anticipate the future, while in Waddell's compositions space awaits the aleatory gesture, the melody of paint, and the horizon is both a stress line and the curve of the romantic notion of possibility. Just as jazz players pin down the melody of an abstraction such as *the shadow of your smile* in a series of notes, Waddell captures the lyrical evanescences of light and color—*grass pushing up through snow*—in the sgrafitto and sfumato of oils, in the drips that remind you, again and again, that this *is* paint.

That ability to capture light in oil is very much in evidence in the most recent paintings, as seen in the concentrated density of the horizon in *Red Willow Angus* (1998). This ability is particularly apparent in the lush and dripping efflorescence of *Montana 2000* (2000) (pages 134 and 135), in which towering fields of clouds become a swirling abstract sublime where we witness mutable events in the process of becoming a concentrated eternity, an emotional spectacle of nature made visible by the artist's pushing the paint to the point where limitlessness becomes visible.

Exploration, it has been said, is the archetypal behavior of getting lost on purpose in order to find something. Waddell wants to know where he's been, even if he can't know where he's going, and his explorations propose a correspondence between states of mind and states of nature. Here it is the fluid exchange between the two that produces the drips, that creates the cryptic hieroglyph that we as viewers translate into a perception of nature. The earlier works tilted your line of vision down and into the painting; now the canvases lift your eyes up and outward into beckoning vistas of paint, taking you from what you think you know to what you don't. In works such as these, Waddell is orchestrating the patterns of his own internal icons, exploring their possibilities—no matter how ephemeral or difficult to grasp—as if they were notes on the musical staves of what we have agreed to call landscape. What we see is an illusory fantasy of meaning, and it is a beautiful one.

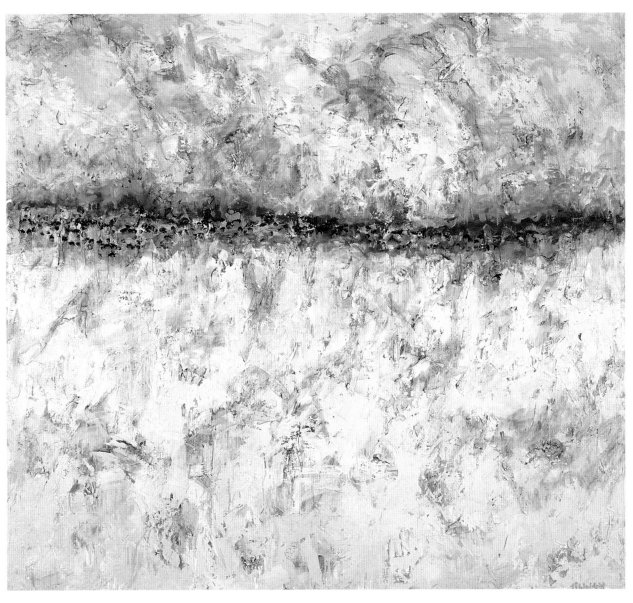

Red Willow Angus (1998); oil and encaustic on canvas, 66 x 72 in. Collection of the artist.

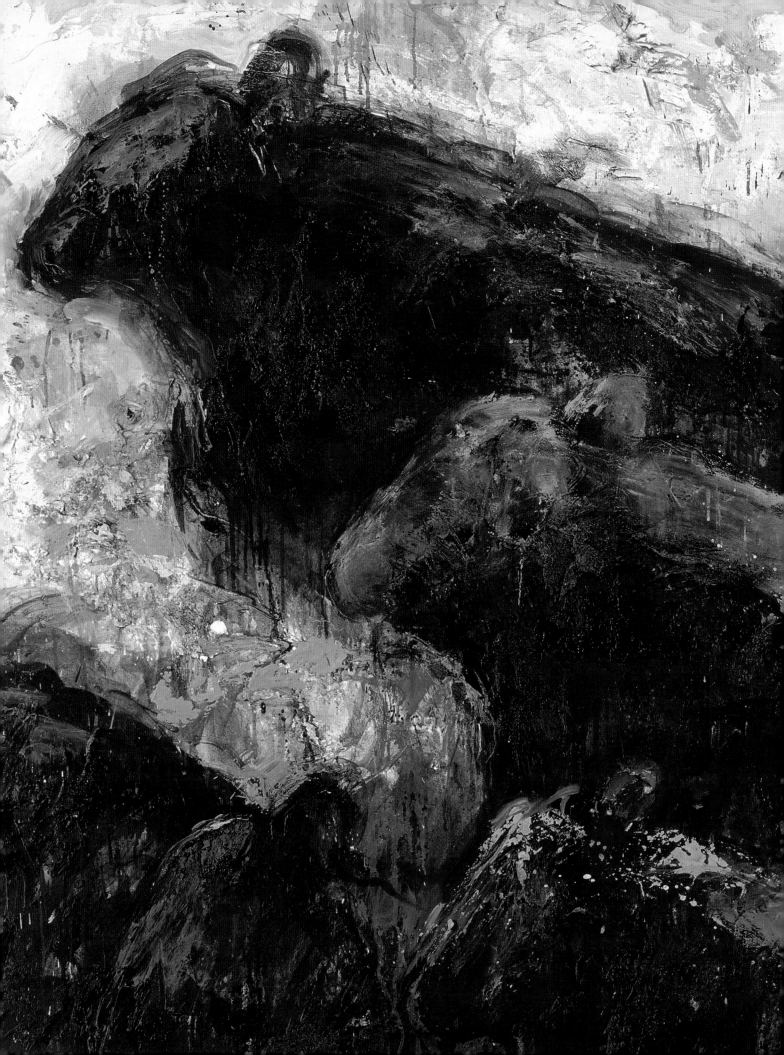

INTO THE HORIZON

BEN MITCHELL

Ted Waddell's Montana home and studio sit on the broad plain of the Gallatin River valley outside Manhattan, Montana. Windows at the back of that studio frame a small, fast-running creek flowing beside the house, and several miles of field and meadows dotted with Angus cattle, all of it held in by the steep west-facing massifs of the Bridger Mountains. Settled in there alongside the Gallatin, he is only a hundred thirty-five or so miles west of Laurel, the small Yellowstone River valley town where he grew up in the 1940s and '50s. In the winters, he and his wife, the photographer Lynn Campion, migrate south to their home and studios in the Idaho Rockies down the valley from Ketchum. It's their little joke, this southern migration from the Montana to the Idaho Rockies. His Idaho studio, just past the horse stalls, looks out on the great hulking shape of Russian John, one of the dominant mountains in that nook of the Rockies.

Place is character, as Walter Van Tilburg Clark once observed about Western writing, and *place* is as inseparable from, as native to Ted Waddell's identity and the work of his art as ticks on a dog. Finding a path toward understanding his methods and subjects takes us through many names and locations, and is essential to understanding the presence and meaning of place in his art. *Firehole River, Lavina Horses, Angus #8, Alzada Angus, Iris Creek Angus, Monida Angus, Russian John, Ennis Mare*. Place and animal together right through. Enough said.

My first meeting with Ted Waddell took place two years ago, soon after I arrived in Montana. It had been a mild, by-and-large open winter, and he'd decided to return a little early from Idaho to his Montana studio to spend a month alone painting. The studio was crowded with new work in all various stages of completion. Paintings covered the walls and were stacked along the floor, singly and in groups. Pots and jars were crammed with brushes soaking in turpentine. Pigment lay in pools on his enormous palettes, and dripped off the edges onto the floor. A big pan of wax sat on a hotplate all boiled over, encrusted like something out of the fourth act of *Macbeth*. Small models of horses were scattered about on the worktables, on their way to bronze casting. But the paintings—landscapes dominated by blues, shot through with pinks and oranges and brilliant whites, scattered with Black Angus cattle and ranch horses —held another world. They wrestled with the mass and presence of the land, with the relationship of domestic animals to that land, and with light. The mysterious, perhaps ineffable dialogue that our very presence sets up with the horizon was a central subject in all the paintings. The horizon, whether in its presence or absence, is after all that mysterious edge where air and soil must somehow join, an ever-

Musselshell Angus #6 (1991); oil on canvas, 66 x 70 in. Collection of the artist. (detail)

present boundary that dominates the northern plains landscape where Ted Waddell grew up. It marks the rim of the world where he has ranched and painted for so long, and is one of the inescapable subjects in his work. His paintings, especially those of the past decade, are increasingly bent on exploring elemental nature, and are daringly empty, devoid of narrative incident or superficial prettiness. His agitated, loose brush—inventive, all motion—conveys a poetics of sensation and impression. It's an immense dialogue to sustain, and not every attempt is fully brought to the ground. But even his grandest conversations are suffused with integrity, with the willingness to risk and at the same time perhaps to fail. Yet always there is the willingness to *see*—and, when you're either fortunate or have worked hard enough, to see anew.

During that first visit, we'd talked for several hours about painting, raising children, cows, sheep, dogs, combining wheat, baling hay. Toward the end of the afternoon, wanting a little pocket of time to get my bearings, I wandered to the back of the studio and stood looking east out the large windows at the Bridgers. There was still plenty of snow in the high country. The grasses in the pastures on the valley floor threw off their first green haze, a green that lasts so briefly in this country. After a bit Ted walked over, fresh cup of hot tea in hand, and joined me. Following a short silence, and in response to no spoken question at all, he said in a quiet voice almost to himself, "You know, this last month being up here alone working, I feel like I'm finally beginning to learn something about painting." That's the voice of an authentic painter.

With his roots in those small-town Western horizons, but also in Western narrative art, American Impressionism, mid-century Abstract Expressionism, and then minimalist sculpture, a Montana boy who taught art at the University of Montana for almost a decade and then ranched for over two, Ted Waddell has been exploring the essential elements and challenges of landscape painting for over forty years now. Nakedly conscious of his place in the long and freighted tradition of painting, and specifically painting of the American West, Waddell is a near-mystic in his relationship to the act and materials of painting itself. Cantankerously and passionately married to a place that is now being chewed up and spat out by gluttonous developers and rapacious corporations, he is an obsessive, fiery, disciplined painter. In his work, the complex visual records earlier laid down by Constable, Turner, Cézanne, and Monet intersect with the American extravagance of Thomas Cole, Asher B. Durand, and Thomas Moran, and with Albert Bierstadt's immense vistas and especially his intensely observed private detail studies. The mid-century experiments and discoveries of Pollock and de Kooning inform his work as well, as do the muted but no less present narratives of Fredrick Remington and C. M. Russell.

Landscape—that rich, cacophonous, and deep vein that is ultimately the most important and sustained tradition in American art—is the tradition within which Ted Waddell works, and works so consciously. Within it lie all the tales of exploration through paint and history of our relationship to this large and little-understood land we call home. For Waddell, this is the context in which his paintings, the core of

his large and varied body of work—more later on the early sculpture, drawings, and assemblages—are a sustained recitation, a meditation on what it is to fully experience the land itself. Though he'd be likely to argue with the strong scent of Christianity in the writings of Emerson and Thoreau, Ted Waddell nonetheless works in the extensive but as yet far from played-out tradition of American Transcendentalism. "Standing on the bare ground, my head bathed by the blithe air, and uplifted into infinite space, – all mean egotism vanishes. I become a transparent eyeball; I am nothing; I see all; the currents of the Universal being circulate through me . . ."[1] His touchstone, like Emerson's, is *seeing* itself, the very act of perception.

The quality of vision Emerson describes, that unclouded lens—an unegotistical "transparent eyeball"—is present here and throughout all the works described in this narrative, and is an essential clue to what Waddell seeks in his painting. He's simply unafraid to fail—a quality separating him from the far more predictably successful and ultimately superficial Western painters who, rather than seek their own voice as he has, merely imitate the past. He just knows this: "The more I paint, the more I learn and the more there is to learn."[2] Each time he looks, each time he paints, he is that *transparent eyeball*, the seeker who brings back to the world in his paintings the fullest possible experience and sensation of what it is out there on the land. In *The Maine Woods*, Thoreau said, "Talk of our life in Nature—daily to be shown matter, to come in contact with it—rocks, trees, wind on our cheeks! the *solid* earth, the *actual* world! the *common sense*! Contact! Contact! *Who* are *we*? *Where* are *we*?"[3] Those too, or something very close to them, are Waddell's questions, reflecting his aesthetic roots, which run deep in nineteenth-century Romanticism. None among us can perhaps know the directness of this *contact* that Thoreau rhapsodizes more intimately than the northern plains rancher feeding cattle at forty below in the dead of winter with a full blow on, or staggering from heifer to heifer during calving season in a cold barn at two in the morning. (Aside of course from women who have given birth.) His art is not the result of some armchair romanticizing, or of the occasional horse-packing trip with freeze-dried food and a titanium espresso machine. Throughout his career, his work as a rancher—and he has only recently been able to give up full-time ranching—and the work he does as a painter, fully meet in his art. There, both the subject itself and the visceral, often haunting, sometimes luminous paintings he makes out of that subject are grounded in direct experience. It is, as Peter Hassrick earlier had it in his telling phrase, *affectionate labor*.

> **There is a property in the horizon which no man has but he whose eye can integrate all the parts, that is, the poet.**
> EMERSON

Ted Waddell was born in Billings, Montana, on October 6, 1941, and grew up just fifteen miles west up the Yellowstone River in Laurel, a small railroad town on the Northern Pacific line. His father, Teddy,

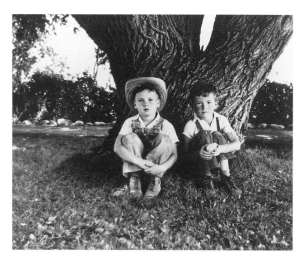

Ted Waddell, left, with childhood friend Brent Noel
in Laurel, Montana, ca. 1947–48; photographer unknown.

painted boxcars for the company. Their house was near the tracks and the now long-gone roundhouse, and he remembers waking and going to sleep daily to the sound of the big locomotives rumbling, dinging, and puffing twenty-four hours a day in the yards. His mother, Katie, still lives there today. Like everyone else, he went to the local schools. In the sixth grade he was introduced to music, took up the cornet, learned quickly, and was soon playing in a dance band—on the weekends helping load a Hammond organ in an old convertible and driving around the area playing dances in the little country towns of Rapelje, Columbus, Big Timber, Broadview, Ryegate. It was also at this time that one of his friends found a Will James sketchbook of horse drawings at the public library, and he began copying those drawings endlessly, along with absorbing everything he could find of the visual narratives of Fredric Remington and C. M. Russell, and their lesser peers. He also went to the library regularly with his father and checked out books—Westerns. He read all of Zane Grey, along with Will James's popular novels, and other Western writers. Later his father spent the winter evenings doing paint-by-number paintings. Waddell watched him intently—he remembers the elaborate setting up as a near ritualistic operation. He wasn't allowed to paint, but spent hours looking on in fascination.

WILL JAMES (1892–1942), *Untitled* (1931);
graphite on paper, 12⅝ x 11⅝ in.
Yellowstone Art Museum, Permanent Collection, Gift of Virginia
Snook. Image copyright the Will James Art Company.

WILL JAMES (1892–1942), *Untitled* (1924);
graphite on paper, 12¼ x 11⅝ in.
Yellowstone Art Museum, Permanent Collection, Gift of Virginia
Snook. Image copyright the Will James Art Company.

CHARLES M. RUSSELL (1864–1926), *Buffalo in Winter* (1912); oil on board, 6½ x 11¾ in.
C. M. Russell Museum, Great Falls, Montana.

Pretty typical roots for a western kid growing up in Montana in the postwar years. But also curiously charged roots, in the intense way certain of our childhood experiences have, becoming talismans that deeply imprint our lives. As with the painting, so intimately tied to his father. "My earliest memory of my dad was smelling paint on his clothes . . . When he came home he had paint on his clothes, shoes, everywhere. I have always loved the smell of oil paint. Still do. There's a magic to oil paint that is unsurpassed by any other medium or activity. The notion of loading a brush with a big dollop of paint is about as good as it gets. The sensation of developing a line or shape with this material is wonderful." Then there's the music that was so much a part of his childhood and teen years, today present in his love of traditional jazz and the way he brings the jazz process to bear in his compositional strategies for the paintings. And in between, hunting and all its male rituals, so much a part of any boy's life in the West then, which he has turned into the funk assemblages and eccentric sculptures that he's been working on for several decades now.

Following high school graduation in 1959, Waddell enrolled in Eastern Montana College (now Montana State University – Billings) to major in architecture. Fortuitously, it turns out, he flunked the required math. Meanwhile, though, because he was deeply interested in art, he was already enrolled in Isabelle Johnson's painting class. "After a few days with her and paint, I decided that was what I wanted to do for the rest of my life. That was forty-two years ago," he says. The imprint Isabelle Johnson was to make on Ted Waddell's career was enormous. Montana's first modernist painter, Johnson was deeply tied to the nineteenth-century European traditions of Impressionism and Postimpressionism. While at Eastern, Waddell studied for two years with Johnson, Ben Steele, and Lyndon Pomeroy. Then came a big break,

when in 1962 he went to New York on a scholarship to study at the Brooklyn Museum Art School: He'd overheard Isabelle Johnson talking with another student in the halls about the opportunity, applied for the scholarship himself, and got it. The summer of '62 he lived in Provincetown making art and selling it on the streets. He was drafted that fall and spent two years in the Army in California and Texas, playing trumpet and touring with a big band doing its bit for recruiting.

In the spring of 1965, back home, he married his high school classmate, Betty Leuthold, and the young couple moved to Billings that fall. Majoring in Art Education, he finished his degree at Eastern. It was also during this period that he opened a little storefront gallery on Billings's South Side and first began working with metal and making sculpture. The so-called 34th Street Gallery—it had no formal name, wasn't any kind of commercial operation—quickly became something of a bohemian gathering place for artists working against the dominant Western narrative traditions, the precious few of them there were in the 1960s interior West. The group that gathered at the gallery, including the founding director of the Yellowstone County Art Center (now the Museum), Terry Melton, began showing work and meeting together at the gallery and generally raising all manner of hell. The headiness of the gallery activity and his work with the sculpture got Waddell interested in graduate school, and he applied and was accepted to Cranbrook Academy of Art in suburban Detroit. Deferred for admission until the following semester, he decided to go downtown and take some classes at Wayne State University. He liked it so well—there was a strong sculpture department there at the time—that he never did go back to Cranbrook, finished his MFA at Wayne State in 1968, and was immediately hired to teach sculpture and design at the University of Montana, in Missoula.

There is the preliminary survey map for Ted Waddell's vision: coming of age in small-town Montana in the postwar years when the whole extent of south-central Montana's plains, prairies, and the Rocky Mountain front was isolated and sparsely populated. A father he adored and emulated, who came home each day splattered with oil paint and smelling of the turpentine he cleaned up with, who loved to read and paint-by-numbers. Teenage years riding the long stretches of empty roads on weekends with a dance band, or with buddies looking for mischief, stopping from time to time to take shots at geese in the potholes, antelope browsing in the sage and bunchgrass, mule deer working the edges of hay and wheat fields—if the season was right or not. And the happy chance of finding, early, a gifted, charismatic art teacher, a teacher, oddly—even eccentrically for that time—not working in the dominant Western narrative tradition of heroic and sentimental history and wildlife painting. Under Isabelle Johnson's guidance, Ted Waddell dug into and completed his early formative training. So central is her story to the art of Montana, and so to Ted Waddell's story, that it bears telling, even if briefly, here.

> I believe there is a subtle magnetism in Nature, which, if we
> unconsciously yield to it, will direct us aright.
>
> EMERSON

Born in April 1901 on her family's Stillwater Ranch outside Absarokee, Montana, on the northeast slopes of the Beartooth Range where they had begun homesteading in the 1880s, Isabelle Johnson was a remarkable and unusual woman for her time—or perhaps any time. Not only did she have a BA in History from the University of Montana, she had an MA in History from Columbia University (then College), in New York. Following Columbia, she studied at the Art Students League and the Otis Art Institute, both in New York, and then at the Los Angeles County Museum of Art and the University of Southern California. In 1946 she was selected by Henry Varnum Poor, the prominent and visionary East Coast painter, as one of the first cohort of twenty-five students for a new experimental school in Skowhegan, Maine, the Skowhegan School of Painting and Sculpture. Perhaps most significantly for our story here, in 1955 and '56 she studied and traveled throughout Europe, where she saw and absorbed the lessons of the Impressionists and Cézanne and their radical aesthetic discoveries.

Isabelle Johnson, ca. 1970; photographer unknown.

It was Cézanne especially, as Terry Melton notes earlier, who became her touchstone. Melton gives a clear picture of this in another comment from 1971:

> To say that she was a well-schooled painter who ranched might have only a slight edge over a well-informed rancher who painted. Therein lie the real essences of Isabelle Johnson's work. Her drawings and paintings are essences of Absarokee, the home ranch and the magnificent Stillwater country of southern Montana. Her pictures are totalities of fragments of that great country: smells of cattle; grassland; sheep and river; sounds of the North Wind and the Chinook; documents expressive and factual of living, growing things, knowing all is tempered by the coming of winter of the land, but never the winter of the spirit.[4]

From the mid-1920s until 1961 Johnson taught in the Billings Public Schools and at Eastern Montana College, where she finished her teaching career as chairperson of the small art department. She spent her life ranching, teaching, and making authentic and singular art in a region dominated by the hegemony of traditional Western narrative illustration, wildlife pictures, and contemporary versions of the sanitized, romanticized, mythical landscapes of a West-that-never-really-was.

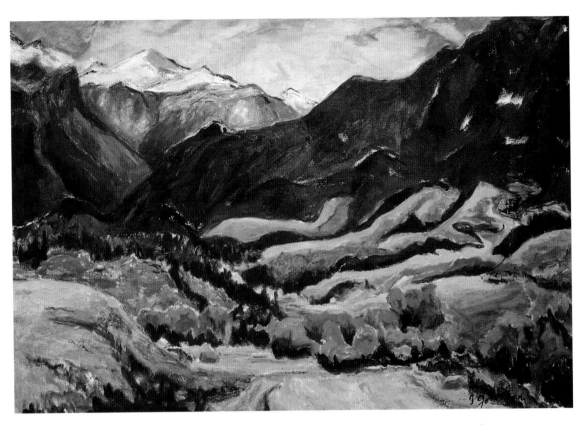

ISABELLE JOHNSON (1901–1992), *East Fiddler Creek* (1967); oil on canvas, 36 x 46 in.
Yellowstone Art Museum Permanent Collection.

In a 1992 Yellowstone Art Center exhibition brochure, longtime Art Center director Donna Forbes, who, along with Terry Melton, had early recognized and championed Johnson's unique position as a modernist painter in the region,[5] said of Johnson:

"A sense of place" has become the usual descriptive nod given to those visual and literary works that loosely fall under the category of regional. Yet no Montana artist since C. M. Russell has had such a profound sense of place as Isabelle Johnson. She saw this hard, rocky, handsome land with a painter's eye, and a rancher's sensibility.

It was a lonely business, being a painter in Montana back in the 50s and 60s. Isabelle had been warned, while studying at Columbia, that if she returned to her home, there would be no one to understand the artist's struggle, no one to discuss those intriguing complexities found within a canvas. She would have to be her own critic. Few rewards. Obscurity.[6]

Johnson herself said, in an unpublished interview with Terry Melton, "To me, the process of being an artist is a becoming, that you never really *are*, until after you're gone; it's for someone else to say that you are the artist or not. Because the moment you stop learning and proceeding and attempting to do these things, you cease to be what the term art really means, whether it's in painting, or music, or any

other form."[7] For the publication accompanying another Yellowstone Art Center exhibition of Isabelle Johnson's work, in 1986, Donna Forbes invited Terry Melton, the Grass Range artist/rancher Bill Stockton—one of Isabelle's few aesthetic peers in the region—and Ted Waddell to submit brief comments on her work. Waddell wrote:

> After my initial contact with her over 25 years ago, I decided to try to become a painter too. She has always been my teacher, in a traditional academic setting and by her example . . . So much of what I thought had originated with me has been appropriated from Isabelle, almost by osmosis . . . Isabelle's consistent and insistent dedication to her vision illustrates the kind of love and discipline that we would all like to have . . . A sense of place, continuity, and history, nearly gone from our culture, is part and parcel of these paintings as well as a wonderful sense of the timely and timeless.[8]

Johnson's impact and influence on Ted Waddell's painting and his attitude as a painter are difficult to overstate. To this day, Waddell brings to each of his blank canvases the enduring, deeply absorbed knowledge that the work of the faithful artist is one of seeking, exploring, becoming. And the knowledge that the artist is always likely to be risking more than he knows. Beyond the sense of aesthetic gesture and the compositional strategies she inherited from Cézanne and the Postimpressionists and conveyed to Waddell, as important as these are, Johnson gave him a gift far more profound: the *spirit*

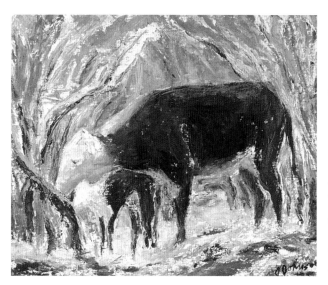

ISABELLE JOHNSON (1901–1992), *Newborn in Storm* (1966);
oil on board, 20 x 24 in.
Yellowstone Art Museum Permanent Collection, Estate of Isabelle Johnson.

of the artist, the fundamentals of what it is to try each day to see, and to see freshly. She said, "I think all art is really primarily religious, not religious in the sense of Christianity necessarily, but that you have to rise above yourself and connect yourself with humanity as a whole if you're going to be successful or really do something as an artist."[9]

After her long teaching career, and having helped her brother and two sisters run the ranch all those years as well, Isabelle Johnson died on May 13, 1992, at the age of 91, thirty years after retiring back to the home ranch. Just a few days after her birthday, she went while at work in her much-loved Absarokee flower garden. In her best paintings—and there are many of these—*Ghost Town, Winter*; *The Chinook*; *Newborn in Storm*; *Feeding Cattle, Winter*; *East Fiddler Creek*—the basic tenets of her art are always present. In ways that Waddell's paintings also do, hers explore not the pursuit of perfection or some kind of imagined, idealized verisimilitude, but purely pictorial problems, and attempt to seize the feeling, the pure sensation of a locale. In a painting like *East Fiddler Creek*, for example, the rudiments of the landscape—the mass of land,

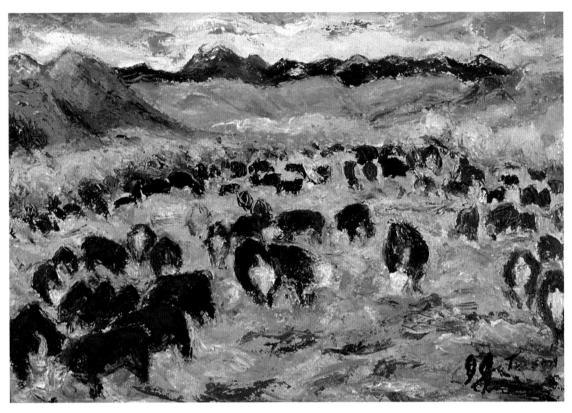

ISABELLE JOHNSON (1901–1992), *Feeding Cattle, Winter* (1956); watercolor on paper, 15 x 19 in.
Yellowstone Art Museum Permanent Collection, Estate of Isabelle Johnson.

the sheer enormity and sweep of Montana's mountains and high plains, the blunt, physical presence of rock and space—are all distilled, refined, made quintessence rather than record. We can see the cows that Waddell will paint already present in her *Newborn in Storm* and *Feeding Cattle, Winter.* She conveys the intimacy and instinctive presence of the animals as perhaps only a rancher can. The pigment is often troweled on with the palette knife. There's a toughness on the surface, a coarseness of texture and shape, and finally a reductive compositional energy that, amazingly and unpredictably, delivers the opposite feeling to the viewer: a sensation of fullness and of openness.

In Johnson's paintings the clarity of the vision has been arrived at indirectly, as if sidewise, through *essence*, rather than by means of any transient verity. In a determination to make it work born out of both the intensity and the ordinariness of day-to-day

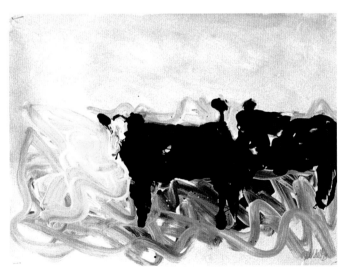

Angus Drawing #11 (1983); oil on paper, 22 x 30 in.
Collection of the artist.

life—keeping sheep and cattle alive and healthy in high, harsh country where the weather and the predators are always allied against you—her paintings celebrate the places, work, and life she loved. But beyond this, the paintings also *transform* what it was that she saw and knew—the land itself, harsh, stark, austere, and the animals that live there—into metaphor for experience. This is what Waddell must have absorbed from her paintings, by her example. In her paintings he surely sensed the place he would have to carve out for himself as a painter, with his own voice: the awful and exhilarating obligation the artist has to authenticity.

> **Nature's dice are always loaded. . . . in her heaps and rubbish
> are concealed sure and useful results.**
>
> <div align="right">EMERSON</div>

In 1968 Ted and Betty Waddell and their first daughter, Arin, who had been born in Detroit, moved into a little farmhouse near the small town of Arlee just north of Missoula, and he began teaching at the University of Montana. As isolated and remote as Missoula, Montana was (and many would say still is), the department he joined included the pioneering ceramicists Rudio Autio, one of the founders of the Archie Bray Foundation,[10] and Jim Leedy (then teaching art history), who would later go on to the Kansas City Art Institute and help build a strong studio ceramics program. Over in the English department, the poet Richard Hugo was building one of the best and most vital creative writing programs of the time, alongside Madeline DeFrees, a young writer and gifted teacher, and later William Kitteredge, who, it bears saying, also knew a few things about ranching in the isolated West, having run his family's enormous ranch in southern Oregon's Great Basin country. The English faculty also included Leslie Fiedler, the important literary critic. Montana's writing program brought writers to Missoula from all over the country. The art department, with the draw of Autio and Leedy's presence, also regularly brought many artists to town, including return trips for that Montanan who had decamped to California, the eminent ceramist and sculptor Peter Voulkos. Waddell taught for eight years, until 1976. Then he quit, in the same year he was granted tenure and associate professor rank, because, he says, he simply felt like he wasn't doing his job.

In those eight years he lived in the mountains, he created many minimalist-influenced, polished stainless steel and Cor-ten steel sculptures. He had first begun working with metal back in undergraduate school and had majored in sculpture and printmaking at Wayne State. As beautiful and occasionally successful as these works were, on the whole they remain pretty much in the school of and beholden to the mid-century visual vocabularies introduced by David Smith and then pared down by Donald Judd. All untitled, save *Feed Block* (1979), now sadly lost, the best of these (pages 80–83) possess an elegance and militant monumentality that holds up today. Of that work, Waddell says, "When we were living in the mountains, making sculpture made sense, and it fit within the context of the narrow mountain

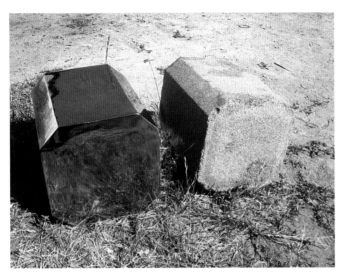

Feed Block (1979); stainless steel, 12 x 15 in. Location unknown.
Photograph by the artist.

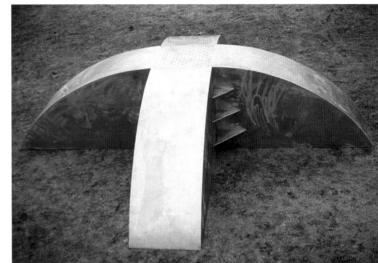

Children's Slide (1974); stainless steel, 3 x 12 x 12 feet. University of Montana,
Missoula, Montana. Photograph by the artist.

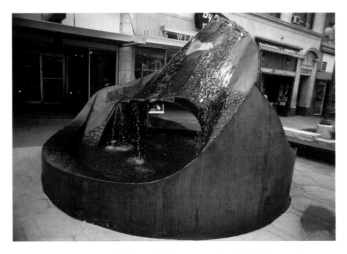

Mountain Fountain (1977); Cor-ten steel, 9 feet high, 14 feet
diameter. Helena, Montana. Photograph by the artist.

Untitled (1971); stainless steel, 12 feet high.
Arlee, Montana. Photograph by the artist.

valleys. Scale fit." Many of the pieces are maquettes for proposed larger-scale works or public commissions. Today, one can come across some of these almost thirty-year-old works in most of Montana's bigger towns—Helena, Great Falls, Bozeman, on the campuses of the University of Montana in Missoula and Montana State University-Billings, and at the Lutheran Church in Polson. Though an uneven body of work, nonetheless the best of these public sculptures—the Lutheran Church commission (1969–70), the *Children's Slide* (1974) on the University of Montana's campus, the *Mountain Fountain* (1977) in Helena—are quietly and elegantly graceful, lyrical and elegiac.

During the summer of 1976, Waddell and his family—their second daughter, Shanna, had been born in Missoula—moved out to one of his in-laws' family ranches west of the little town of Molt, just north of his hometown of Laurel. Though he had no background for it, for the next eleven years he was the ranch manager, running two hundred cows, over a hundred head of sheep, and farming hay and winter wheat, all on 4,500 acres. It was a big change. Laurel wasn't a big town, but Ted Waddell didn't grow up ranching or farming, either. Those first years on the family ranch he had a lot of learning to do. One of his childhood friends, Les Frank, who did know a thing or two about ranching, tells the story of one year in the late '70s when the winter was particularly unending and brutal. Hay was in short supply throughout the west and stock was everywhere starving. Waddell hatched the idea—this is an artist thinking—that because agricultural-grade molasses was really cheap and everyone had plenty of straw, as a by-product of wheat growing, he'd buy up a bunch of fifty-five-gallon drums of molasses, soak chopped straw with it, and get his cows fed. Les and others thought this just about the most hare-brained scheme they'd ever heard. But Waddell got his herd through. There are dozens of stories like this from those first ranching years.

Untitled (1971); Cor-ten steel, 10 feet high.
Arlee, Montana. Photograph by the artist.

> The health of the eye seems to demand a horizon. We are never tired, so long as we can see far enough.
>
> EMERSON

After the move to the Molt ranch, Waddell turned away from minimalist sculpture, breaking his style to begin making drawings—what he calls his oil paintings on paper. The change is easily understood—it is driven, like all his work will be, by the place itself. As he told me, "On the prairie where you can see for 150 miles in any direction, sculpture made no sense to me. I couldn't afford to make sculpture on the scale necessary [for it] to make sense, so I went back to drawing and painting—drawing first—and then, after feeling the need for a scale change, painting our black cows." In those years, roughly 1976 through the middle '80s, he made more than 600 drawings. He has always been, and continues to be, remarkably prolific—with a foundation in both sculpture and printmaking, he often works out his ideas first on paper. Of those first works in oil, the significant majority are studies of the horizon. Sustained, energetic, compulsive, the drawings are a coming to terms with the ever-present and sometimes overwhelming edge of the northern plains, one of the most remarkable natural features you confront in the landscape of central and eastern Montana (and the Dakotas and western Nebraska for that matter). Sometimes first-time visitors who take the time to stop the car on I-90 or 94 somewhere outside Glendive or Miles City, Lodge Grass or Crow Agency—or, traveling up on US 2, the High Line as it's called in Montana, outside Wolf Point, or Glasgow or Malta—out there on the plains you can get downright spooked at how big that solid ocean of land is, how you can sense the earth's curvature, how the relentlessness of the wind sets everything vibrating, as if the land itself is trembling with some kind of anxious anticipation. In *Bad Land*, his 1996 study of the settling of eastern Montana, Jonathan Raban describes the place this way:

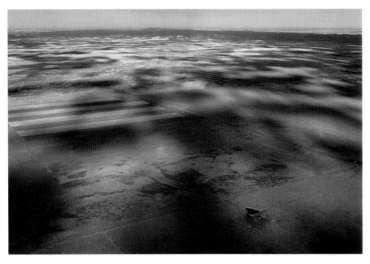

LARRY MAYER, *Eastern Montana Prairie* (1996); color photograph.

> [It was] country that defeated the best efforts of the eye to get it in sharp focus. It went on interminably in every direction. In late summer . . . the yellow land looked like bad skin—a welter of blisters, pimples, bumps and boils. With no trees to frame it, no commanding hills to lend it depth and perspective, it gave people vertigo. You couldn't get your bearings—or, rather, you had no sooner selected them than they went absent without leave. . . . It was scary country in which to take a stroll. You felt lost in it before you started. It was not quite raw land, but nor was it a land*scape.*[11]

Cloud Drawing #37 (1984); oil on paper, 19¾ x 25¾ in.
Collection of the artist.

"From one point on the ranch," Waddell says, "I could see the Crazy Mountains, the Beartooths, the Snowy Mountains, and the Pryors. I have always loved being able to see far, and whenever I was away from the plains too long my eyes ached for them." The astonishing openness, unrelenting emptiness, ruggedness and austerity, the slashing scar of horizon line—and the cows, sheep, and horses living within it—together became one of Ted Waddell's essential motifs, the subject that led him to his first successful, riveting, haunting, sometimes scary, often luminous paintings.

The seeds of instinct are preserved under the thick hides of cattle and horses, like seeds in the bowels of the earth . . .

THOREAU

About the period when he turned from large-scale sculpture to drawing—a first-time rancher and father of two youngsters has precious little time for art-making—Waddell remembers, "The smooth formalism of Donald Judd that had influenced me in graduate school didn't make sense on the prairie, the ranch. Everything on the ranch has a tactile, sensual quality to it. It is about texture, smell, appealing to all the senses." The turn took some time though. The earliest drawings remain cooler, cerebral, self-consciously modernist. *Molt Series, Thompson Sunrise #2* (1977), to take one example, is typical of dozens of drawings he made following the move from Arlee. In those earliest images, the components of the northern plains landscape are strongly compartmentalized, marked off gridlike with the dense, monochromatic mass of the land weighing down the foreground, a brittle horizon line, featureless or stylized sky and clouds, and the presence of man-made structures all angular and intrusive. But he soon began playing with a looser, freer, more interpretive approach, swirling, twisting, and thrusting the pigment about on the paper's surface. In many of these works, the

Molt Series: Thompson Sunrise #2 (1977); pencil on paper, 15 x 22 in.
Collection of the artist.

bunched lines and masses of the cows—becoming more abstracted to marks and blobs—themselves become the horizon line.

49

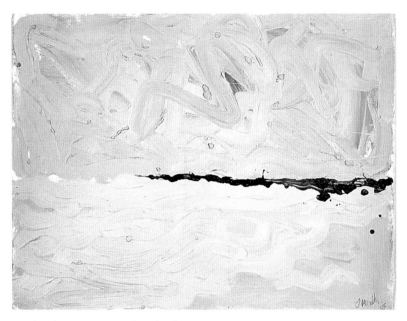

Charolais Drawing #16 (1984); oil on paper, 19¾ x 25¾ in. Collection of the artist.

The best of these works are stunningly expressive, poetic paintings. The 1984 *Charolais Drawing #16* and the 1985 *Landscape, Cloud Drawing #43*, are good, and typical, examples of what he was getting hold of in his drawings from these years. Expansive and open, the colors pulsing and swirling, in these drawings the landforms are becoming much more abstracted, reduced, rarified, cast as elemental, essential. The animals, rudimentary and isolated, often give you the feeling they are melting into the landscape, or marking the horizon with their mass. These drawings represent a prolonged study of that motif—land and animals,

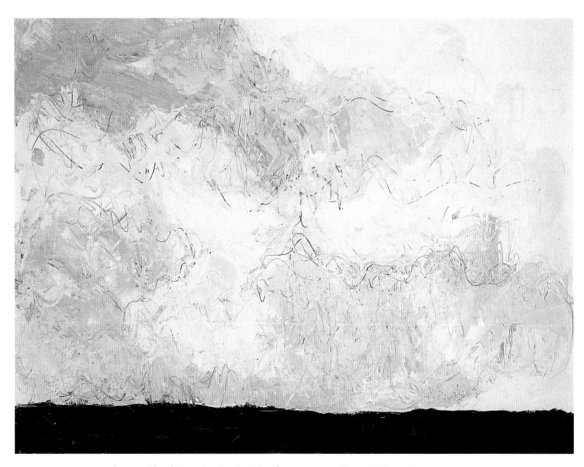

Landscape, Cloud Drawing #43 (1985); oil on paper, 19¾ x 25¾ in. Collection of the artist.

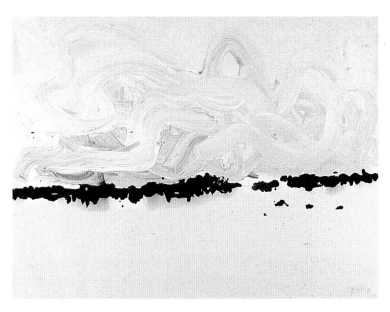

Angus Drawing #54 (1984); oil on paper, 20 x 26 in. Collection of the artist.

close up and in the swallowing distance. In them he is getting at the core of the matter quickly. By isolating elements, paring down the natural world's wealth of detail, and mystery, into the elemental, evocative, and powerfully simple shapes, he is developing an intensely personal visual vocabulary. The insistent horizontality in the drawings is caught fast in the immutable, rock-hard solidity of cow, pasture, horizon, sky. It was as if he had found just how large his pastures were.

In *Angus #130* (1986), the cows stand with that complete cowlike, indifferent haughtiness they have in the midst of a land that can threaten to reduce them, to our eye, to near nothingness. In *Angus Drawing #54* (1984) the animals are becoming nearly completely abstracted, their presence itself standing in for the horizon line. Or again, the whole mass of stock in *Angus Drawing #60-A* (1983) resonates with a Motherwell-like calligraphic presence. The pigment seems flung against the paper. Again and again in these drawings, Waddell seeks to understand light and its play on the eye, often leaving large expanses of the paper raw and empty of pigment, and he is beginning to recognize how, in that peculiar plains light and immensity of space, the relationship of the animals' shapes and the mass of the land intersect in surprising and dynamic configurations. He is exploring the gestures and marks needed to convey sensation, experience, and recognition of weather, land, and animal. These particular essences—that sense of feeling, right down there under the skin, the immensity of the unique northern plains atmosphere itself, the vibrant, powerful presence of livestock in the landscape—

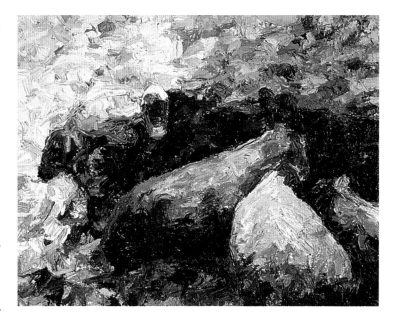

Angus Drawing #130 (1986); oil on paper, 60 x 78 in. Collection of the artist.

are distilling into a brash, expressionist pursuit aimed at putting across the quickened, sucked-in breath of the moment. His pictorial means are emerging with more clarity, more confidence. A voice—his brash vocabulary of line, plane, mass, and color—is strengthening, becoming more muscular.

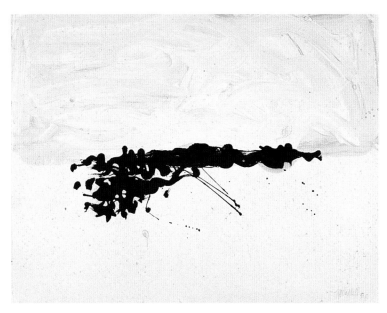

Angus Drawing #60-A (1983); oil on paper, 20 x 26 in. Collection of the artist.

During the eleven years on the Molt place he exhibited hardly at all, but created a huge body of work—the drawings—and his first landscape paintings. Taken as a whole, these works are an insistent struggle with the relentless geometry of geology and landforms, with mass, light and sky, and, more profoundly, with the sheer presence of the horizon line, and the way that line both contains us, by marking the edge, yet is vastly open. Though cattle, horses, and sometimes sheep are increasingly present, and become his central motif for a period of time in the middle 1980s—his obsession, really—Waddell's essential inquiry in these drawings has to do with the blunt constancy of the plains horizon, the sheer magnitude and presence of that line, and of the clouds above, the ground below. What these drawings are exploring are qualities of intimacy and distance, the magical power of light, and the sometimes uncanny northern plains atmospheric effects constantly at work on the eye. The drawings are compositions enveloped in atmosphere and impression. The English painter Constable, whose cloud studies Waddell's resemble in so many ways, reminds us, "The sky is the source of light in nature and it governs everything; even the common observations on the weather of every day are altogether suggested by it."[12] What Waddell seems to be after in the drawings, as Constable was earlier, is how to convey, on a flat surface with only pigment and a brush at work, the elemental feelings—raw emotion—that we experience in the presence of clouds' motion, the play of shadow across open ground, the inexpressible and mysterious relationship between ground and sky, and, fundamentally, between human experience and natural forces.

Barbara Novak, in her seminal *Nature and Culture*, remarks, concerning nineteenth-century American landscape painters, that they were "uniting art and nature in the votive act of landscape painting" and that it was "a kind of cumulative situation in which aggregations of detail found their

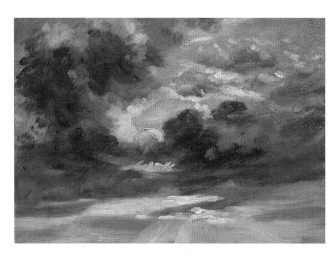

JOHN CONSTABLE (1776–1837) *Cloud Study: Stormy Sunset*, (1821–1822); oil on paper on canvas, 8 x 10¾ in.
National Gallery of Art, Washington, D.C., Gift of Louise Mellon in honor of Mr. and Mrs. Paul Mellon. 1998.20.1

own cohesion . . . the part could stand for the whole, as in a section of a painting by Pollock."[13] By linking the nineteenth-century painters with Pollock, Novak is here making several crucial points, insights that we will see become surprisingly spot-on for Waddell as well: how the part can stand for the whole in the paintings' structure and compositional strategies, painting as "votive act," and the meeting ground between nineteenth-century American Impressionism and mid-twentieth-century Abstract Expressionism.

In those years at the Molt ranch—1976 through 1987—Waddell laid out the foundation for his mature work. Through experiments with drawing, painting, and sculpture, he was now moving toward his own expression as a painter. Light, the intricate geometries of land, the horizon and its omnipresence, all begin to cohere as his first paintings. These works, drawing as they do on Constable, J.M.W. Turner, Jasper Cropsey, Alvan Fisher, and other nineteenth-century landscape painters, and almost regardless of the evenness of their aesthetic stance, mark the point where Waddell's mature painting style begins. Even his most recent paintings, like *Iris Creek Angus* (1999) (page 130), *Monida Angus* (1999) (page 129), *Yellowstone Horses* (2000) (page 133), *Ross Peak Angus #2* (2000), (page 131) are born out of those hundreds of drawings first begun in the late 1970s. Today we can see how these drawings stand as a major underpinning of Waddell's subject and aesthetic, and continue to sustain the subsequent development of his work.

The invariable mark of wisdom is to see the miraculous in the common.

EMERSON

Right through the decade following his move from Arlee to Molt, when Waddell was most deeply involved in the landscape drawings and then the first paintings, he also began making crude, animistic funk sculpture from found objects he happened on around the ranch. These assemblages—including macabre trophy heads, crazy, disturbing body bags for game animals, guns, and other relics—are minor to his painting, but nonetheless are an important part of the whole aesthetic that encompasses his particular western vernacular voice. "It seemed natural to use the materials that were around me," he says. "The trophies started with finding and being fascinated with skulls and bones I found on the ranch. This was coupled with a growing understanding of being responsible for life and death." Sometimes funny, at turns horrific, these works owe much to the West Coast funk art of Robert Arneson, Ed Keinholz, William T. Wiley, and others that spread from the Bay Area, Los Angeles, and Davis and throughout the Northwest. They are a wry, biting commentary on Western mores and vernacular popular decoration. He told me, "The idea of cow trophies resonates with the idea of life and death, and it's a spin-off of hunting. I have been part of a hunting tradition all my life. As a kid I hunted pheasants, ducks, and deer. Not much good, but I did it. I hunted geese for a time—until I found out they mate for

Trophy #6, Cowman (1987); mixed media, 26 x 32 x 22 in.
Location unknown.

life, quit. I haven't hunted for over twenty years. I think the trophies were a response to men who kill things and want to hang them on the wall to be reminded that they have killed something. Who wants to remember that stuff?"

He also pushes the trope deeply. Like some perverse Gary Larsen *Far Side* cartoon, the 1986 *Trophy #6 (Cowman)*, reverses the clichéd trophy image, mounting a rancher's head on the wall, with the center of the face a black void—a frightening work. The *Cowman* series, like *Trophy #6*, are now all mostly lost—sold too long ago before he kept better records, lost in one move or another, or simply disintegrated. The 1988 *Writer Trophy* (page 102), complete with a working IBM Selectric, manages to be both funny and haunting at once, commenting, as it may, on the way in which western Montana has become a haven and refuge for writers following the scent of the chestnut embodied in the overused *The Last Best Place*. In *Anderson's Deer* (page 110) he fuses the regional vernacular with a broader social commentary, forcefully reminding us of the time—not so long ago for us to feel at all removed from the racist poison that infects American culture—that in April of 1939 the great African American singer Marian Anderson was barred from the

Metropolitan Opera stage. If you remember, Eleanor Roosevelt invited her to sing outdoors at the Lincoln Memorial—there were hundreds of thousands in the audience. *Anderson's Deer*, with its matt black finish and the oddly elegant string of paste pearls at the neck, has the uncanny power of a fetish. Likewise, the guns, harebrained as they may seem at first blush, are also fetishes, a disturbing comment on both the prevalence of hunting in Western American culture, and the increasing social danger gun worship represents to us all.

Over several decades now, Waddell has experimented with this infusion of popular culture and funk-like assemblage into the range of his work. There are dozens of old Cor-ten and stainless steel sculptures, bones and skulls, and funk works either in progress or decaying, scattered around the grounds around his studios. The works are like

Horse Shit Mallard (1989); mixed media,
7 x 13 x 16 in. Collection of the artist.

Theodore Waddell: A Retrospective, 1960–2000, Yellowstone Art Museum, 2000. (installation detail)

exclamations—something necessary even if not always as successfully resonant or as visually rich as his paintings and drawings—perhaps like pauses, punctuating the hard work of moving from painting to painting. Clearly they are one continuing, and sometimes absorbing, component of the whole complex of his last four decades of work, standing as outcrops of some kind of necessary regional vernacular. Besides, Waddell is a remarkably hard worker, and when not painting he continues working on the assemblages, on printmaking—a primary concentration when he was a graduate student in Detroit— and has recently begun to work with bronze.

> **The production of a work of art throws a light upon the mystery of humanity . . . an abstract or epitome of the world.**
>
> EMERSON

In the early 1980s Waddell was again looking for a scale change, this time from the smaller drawings, and he turned aggressively to painting. At first he used oil-based house paint and applied it so thickly it ran off the paper or canvas when he worked vertically. So those first landscape and animal studies were painted on the floor—pictures like *Angus #11* (1981), *Angus #15 (Miss America)* (1981) (both page 85), and *Angus #87* (1984). These earliest paintings have a curious folk art–like quality, a warm, naive, homey

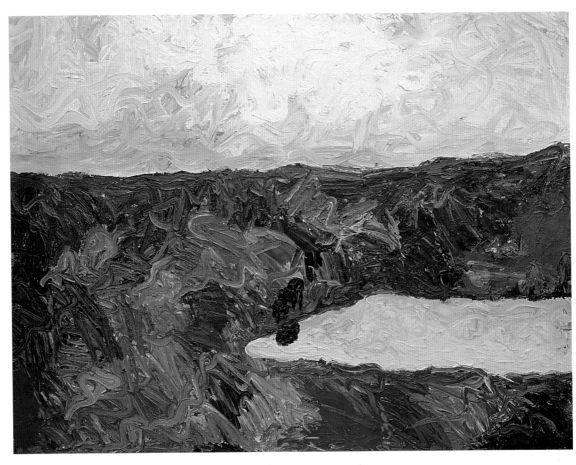

Angus #87 (1984); oil and enamel on canvas, 54 x 72 in. Collection of the artist.

kind of feeling. The colors seem literally poured straight out of the can, and aren't Montana's northern plains colors anyway. The compositions are blocky, the light is flat, and the cows are icons, not the full-blooded breathing critters he was working so closely with day in and day out. They are not much related, yet, to the real, manure-tracked creatures he will soon begin painting.

In 1982 he exhibited a group of the new paintings at the Billings livestock auction yard. They were hung over the sales arena—as the cattle came in to be auctioned, you could look at the paintings at the same time. Says Waddell, "By that time, I had been around these wonderful creatures for about five years, day and night. I started making paintings and works on paper about them . . . I love the notion that the landscape is made special by their presence." Soon after the stockyard show, a Corcoran Gallery of Art curator came out west from Washington, D.C., looking for artists to include in a painting biennial, the *Second Western States Exhibition*, a project sponsored by the Western States Arts Foundation.[14] Waddell's work was among the pieces chosen—there were over one hundred works by thirty artists in the show—and it was a critical moment for him. Both the *Washington Post* and the *New York Times* reviewed the exhibition, and his work was notably singled out in both journals.[15] Soon thereafter, the critic Mark Stevens, who has his own deep ties to Montana (his family maintains a ranch on the east

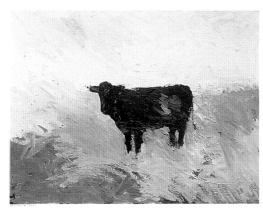

ANGUS PAINTINGS
1982

THEODORE J.
WADDELL

EXHIBITION
BILLINGS LIVESTOCK
COMMISSION COMPANY
Lockwood, North Frontage Road
March 29-April 2, 1982
LONGAN GALLERIES
Level 1-Stapleton Building
Billings, Montana
March 29-April 29, 1982

Billings Livestock Commission, 1982 exhibition poster.

side of the Crazy Mountains where Stevens spends many summers), published a substantial *Newsweek* article called "Art Under the Big Sky," which featured Waddell as well as his friends Patrick Zentz, and Dennis Voss, who has subsequently quit art for full-time ranching and bull breeding. Stevens said of Waddell's paintings, "a person can almost smell manure and the hot sweet hay breath of a herd. The painting itself can be uneven. At its best, however, his brushy style, heavy but fast, evokes both the quirks of cattle and their almost eerie rootedness—their magnificently dumb, earthy force."[16]

Those early paintings first shown at the Corcoran and discussed by the critics—*Angus #s 21, 23,* and *24* (pages 86 to 88)—are emotively beautiful. And starkly instinctive. You can see how close in he's moved in these three early paintings. In them, wholly unlike the prior decade of drawing, the horizon is gone.

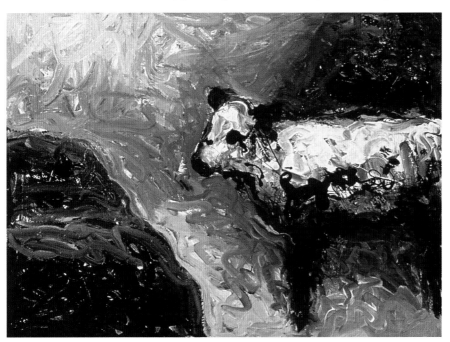

Longhorn #9 (1983); oil on canvas, 36 x 48 in. Collection of the artist.

Or, in a very real sense, the horizon is now weighing down upon us, invisible, but felt. The cows thrust toward us, press against us, and crowd the foreground. Their presence is actual, inexplicable. Writing about those paintings in the *Washington Post*, Paul Richard remarked, "There are so many jokes, quick hits and references to familiar older art in the exhibition, that Theodore J. Waddell's cattle paintings somehow seem quite special. Dark animals, not clearly seen, breathe softly in the darkness, and become part of the landscape. Waddell . . . offers us the opposite of flashy art."[17] Lee Fleming, writing in *ARTnews*, describes these paintings with a vivid eye: "The subtly of the chiaroscuro, the shadowy mounds of the herd that seems, at a distance, to be less

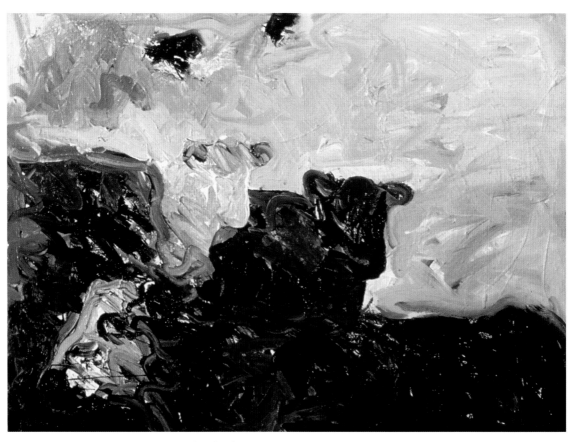

Angus #66 (1983); oil on canvas, 36 x 48 in. Collection of the artist.

cow, more landscape, even the depth of his heavily varnished surfaces, creates a remarkable atmosphere. We can almost feel the impassive hills brooding beyond the darkness of the animal forms."[18]

As the outcome of long years of living with and drawing the horizon line, constantly feeling the presence of his animals in relationship to that horizon, or moving about him in the barns, calving pens, and feedlots, these early paintings convey with elemental clarity and power the presence of land and animal. He is working with *atmosphere*, conveying a near-palpable presence of the animals, and the personification of the landscape—those brooding hills. It is at once fascinating and instructive that several writers here (and many that would follow) note how in these early paintings the animals and the landscape can become the same form, or exchange places, as in the earlier drawings. Much of contemporary Western art, especially the work of traditional commercial landscape and wildlife painters, is maudlin, cloying, and defensively reactionary. Waddell manages somehow—and that *somehow* springs faithfully from a deep intimacy, the hard-bitten intimacy of the working rancher—to wring from the landscape and all its parts of sky, horizon, broken rock, butte, rolling prairie surface, and the animals that graze there, a lush and expressive sensation of presence. Waddell knows, as Simon Shama puts it somewhere, that "It is our shaping presence that makes the difference between raw matter and the landscape." What Thoreau said in his *Journal* on August 30, 1856, still holds true: "It is in vain to dream of a wildness

distant from ourselves. There is none such. It is the bog in our brains and bowels, the primitive vigor of Nature in us, that inspires that dream."[19] These early paintings are a full and vigorous record of this nature, the one deep in our body. Describe it as elemental, earthy, mucky, confrontative, stark, from whatever angle you come verbally to these first paintings, you understand that Waddell has nailed something essential down here—relationships, intersections, animal and land, a closely observed and deeply understood reality of day-in and day-out hard work. The wildly physical application of the pigment, the deep, hide-like impasto, the heavy varnishes, the truncated and in-pressing foreground of animal presence all make these early paintings evocative of hard-won seeing. In the essentials of this art— husbandry, tending the herd and flock, *seeing* the place one lives—he insistently seeks an understanding of the whole through a close relationship with all its parts.

After more than twenty years of apprenticeship, first as a teacher, then as a rancher, and including all those years he worked in virtually complete isolation in Molt, he was relatively suddenly a very popular artist. Following the Corcoran exhibition, which traveled to the San Francisco Museum of Modern Art, among other venues, Waddell signed on with the Stephen Wirz Gallery in San Francisco and the Stremmel Gallery in Reno, Nevada. Contracts soon followed with the Steinbaum Gallery in New York, and galleries in Chicago, Santa Fe, Seattle, and Scottsdale. Throughout the 1980s and '90s, he regularly mounted over twelve commercial gallery exhibitions a year. "Since my phone hadn't rung for twenty-five years," he says, "I was afraid to turn anything down."

> **The works of nature are innumerable and all different, the**
> **result or the expression of them all is similar and single.**
> **Nature is a sea of forms radically alike and even unique.**
>
> EMERSON

The three writers whose words open this volume frame for us the various ways in which the American West is freighted with an enormous weight of cliché, hyperbole, romantic superficiality, sentiment, and just plain bullshit. No other region of the country—well, except Southern California maybe—is so disputed as history, so superficially mythologized in the American imagination. No other region has been so trivialized in literature, music, and—most heavy-handedly—the movies. In a fundamental way, the collection of hackneyed visual images that is the "West"—basin and range topography, badlands, buttes, dust, emptiness, solitary cowboys, noble or forlorn Indians—was formed for us by John Ford and other, lesser Hollywood directors, and popular TV westerns of the 1950s and '60s. It is still being distorted, and in the most sinister way, by the carnivorous visual culture of the advertising industry, where one is offered soaring aerial shots of overblown cars (themselves ironically bearing the stolen remains of Indian nations' names) on the tops of mesas and buttes, rutting creek beds deep in canyons, or careening through herds of horses or the fragmented remnants of coastal forests. Whatever else it may be, the

West is a disputed territory, full of dubious myth, contentious narrative, and conflicting values. In this dissonance, the contemporary painter is left to find his or her own voice. It ain't easy.

It is especially not easy for a painter like Ted Waddell, a working rancher who chose, years ago now, to take this landscape as virtually his singular subject. "I paint animals in the landscape because they are in the landscape I paint. This ground is their ground. They shape it, give it reason for being. It is natural to see them in the landscape. The animals provide a focal point to better understand and accentuate the landscape." We return here, hearing it in his own voice, to *intimacy*, to the ways in which he brings an enormous empathy to his work, a direct involvement with the land itself, with the animals a rancher has to try to keep alive, fed, and nevertheless get safely to market. Through this empathy—a passionate familiarity—Waddell seems to expose for us a bundle of nerves, an awareness of natural forces at work—the vast expanse of the plains limned by mountains, the overarching bowl of sky, those cows breathing in the darkness.

One group of these early paintings, *Longhorn #8, Angus #116, Cloud Landscape #3,* and *Angus #135* (pages 93, 95, and 96) represents an important transition for Waddell, making his final movement away from the earlier minimalism. In his words, "The world isn't like that. It didn't seem important." He backed away from the folklike quality of the first landscape and animal works done with house paint, and moved forward into a deepened inquiry based directly on the drawings, and the pure pictorial space of his own emerging vision and style. He is beginning to work the paint heavily, nervously, even frenetically. Layer upon layer of pigment is laid down and then pushed and pulled about. He was still working with his canvases on the horizontal, and it's as if he is kneading the colors together. *Cloud Landscape #3,* for instance, as much as it and others are related to the drawings, shows the stronger, emerging relationship with the rectangular picture plane, an integrity with the painter's necessarily limited physical world. The compositions are tightening even as his method, the physical act of painting itself, is loosening. Like the sculptor he first was, it is as if he is working his paintings' surfaces much the way he once finished metal. In these paintings a sensation of the purely kinetic is emerging—listen closely and you can hear the faint hiss of pigment moving across fabric, sense the percussive jab of brush against the canvas's resistance. This is the rough music of brush and paint on canvas. Affectionate labor.

Waddell is now beginning to wring from ranching itself, on the model of purposeful hard work, pictures that are evocative of the European Romantic traditions of the sublime, and, when successful, at the same time are honest records of everyday, raw, human experience and emotion. Pictures suffused with both beauty and anxiety. It is no mean achievement, this significant intersection he is exploring. And during these years, many of his paintings are becoming much larger, encompassing expansive masses of color and rough, earthy organic forms that stand for cattle, grass, rock, sky. As Monet, one of his important models, did, it is as if he is reaching out to encompass the world he sees, and to get as much of it down on as much canvas as possible. In a painting like *Angus #116* (1984) (page 93), five feet

by over six feet, the austere plains landscape, the cows filling the mid-ground, and the horizon all eddy together in an expressive world of atmosphere and color. In a 1984 Yellowstone Art Center brochure, then-curator Gordon McConnell said of *Longhorn #8* (page 93) "Poised square with the picture plane, the calf as depicted occupies its world with naive confidence. Where another painter (an illustrator) might be interested in detailing the variegated patterning of colored hair on such a cross-bred calf, Waddell pursues a painterly translation, creating analogy between the factual subject and the expressive medium."[20] This "painterly translation" is everywhere evident in the paintings of the 1980s. As much as the mechanics of painting are vitally important to him—his play with the compositional possibilities and concepts of pictorial space, the way he isolates the animal or herd, how the horizon disappears now in many of the works as he's moved in so much closer both in his experience and in his painterly methods, the bolder handling of color, impasto, the investigation of the strokes and marks and slashes that are becoming his physical vocabulary—what is far more compelling about these early paintings than any technical assessment is the freshness, the surprise, and the authenticity of experience he brings to us. These are cattle (or horses or sheep), the paintings say, and this how it is in the place they live.

Here's the nub of it. There is no myth or cliché in Waddell's early paintings, no Myth of the West, no Myth of the Cowboy. Commercial Western art is top-loaded with the "convincing detail" of the scenic view, the clichéd mountain writ in holy light, magnificent wildlife in pristine settings. The emptiness Waddell courageously explores, the poignant, physical presence of the animals, the impressionistic palette he brings to the paintings—these separate him from commercial Western genre artists. And as large as the legacies of Remington and Russell may be in his past, Waddell's early paintings are empty of narrative—or, to put it another way, he is opening the paintings up beyond any specific story, so that the imagery speaks for itself in ways as various as the places the animals find for themselves in the landscape. Any story they tell is in the vocabulary and syntax of color, form, pattern, mark.

In the woods we return to reason and faith.

EMERSON

Waddell and his family left the Molt place in 1987 for Ryegate, seventy miles due north of Molt, and bought a house near the ghost town of Barber on forty acres hard fast on the north bank of the Musselshell River. They took only an old cow and six yearlings with them. After a time they bought a section of ground across the road, and eventually ran sixty pairs on the desolate, rocky landscape where grass was sparse but the wind was plenty abundant. His neighbors called the ground "Waddell's rock pile." But it was less demanding ranching in most ways—sixty pairs is a whole lot easier to keep track of than two hundred and more than a hundred sheep. Finally, he was no longer managing his in-laws' family ranch: he and Betty now owned their own place. For the first several years, though, to be able to both run the place and paint, he drove a long round trip each day from Billings—they rented a small

house so the girls could go to Billings schools—to west of Ryegate and back. "It wasn't so bad," he told me, "two cups of coffee in the morning and a six-pack on the way back." As he said some years later in an artist statement "I have to be where I am to paint what I paint."

> I feel as if I live in the midst of a large painting and I can pick and choose parts of it to examine. There is a stability to the landscape and the people here, allowing me to examine the same situation over a long period of time, even though the seasons change and people change. . . . This stability allows me to study a place at length and appreciate it very much. There is so much to be learned.

Always indebted to Isabelle Johnson, Waddell absorbed her elemental teaching about what the artist has to do—"an artist never arrives, I think you're always trying to become one."[21] His roots, though, reach deeper into the American Romantic landscape tradition, still a young tradition that began only in the early nineteenth century with Thomas Cole and found its early blossoming in the Hudson River School.

The word landscape itself is a new one, historically. It entered the English language only late in the sixteenth century from the Dutch *landschap*, which signified a unit of human domain, a legal jurisdiction, more than any pleasing scene.[22] Landscape remained largely a European genre grounded in the seventeenth-century art of Rubens, Salvatore Rosa and the Dutch School, the more direct examples of the English Romantics Turner, and Constable, and then those early, operatic paintings of Thomas Cole's.

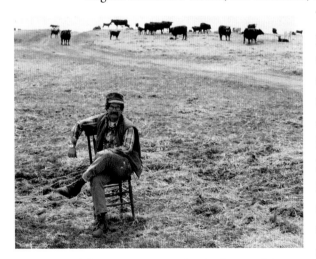

Ted Waddell, Ryegate, Montana (1983); photograph by Frederick R. Longan.

Throughout the first two hundred years of American painting, landscapes were rarely portrayed as themselves, appearing chiefly as a convention in historical scenes, or as convenient and subordinate settings for portraiture. Buried under English landscape traditions, or reduced to decorative elements, landscape was long a secondary subject in American art. It was Cole, his student Asher B. Durand, Albert Bierstadt, Worthington Whittridge, and others of the Hudson River School who in the still-young American nation first revealed and championed the elemental—and deeply spiritual, for this pioneering group of philosophers and painters—*nature* they were led to by John Ruskin's arguments in *Modern Painters* (first published in the United States in 1847),[23] and Emerson, William Cullen Bryant, and other Transcendentalist poets and philosophers. And ironically, the rise of the landscape as an independent genre, remember, was attendant on the Industrial Revolution, which made "nature" both more accessible for new forms of recreation and adoration, and yet also moved to hasten its disappearance.

That long—and essential—history of nineteenth-century Romantic painting, Transcendentalism, and the force and power of Western Impressionism, along with their enduring influence on contemporary painting, is too large a story to do more than sketch in here. It will have to suffice to say that this is the tradition Ted Waddell's work is fully steeped in, with the reservation that, unlike many of his peers painting today in the American West, he is not at all content to re-tell what is already known about that history and visual narrative. Waddell comes at it on the slant, with an acutely personal, subjective intensity. "It seems to me that in art" he says, "you learn to go from what you understand to what you don't understand. And somehow in the process of making marks, one is changed by having done that." He is after a kind of organic vitality in his paintings. The full veracity of experience is his essential subject, the elusive landscape as discovery, possibility, potential.

> It is things which are emblematic. Every natural fact is a symbol of some spiritual fact. Every appearance in nature corresponds to some state of mind, and that state of mind can only be described by presenting that natural appearance as its picture.
>
> EMERSON

The paintings that fall in Waddell's Ryegate period, from 1987 through 1995—among them the *Yellowstone Park Series* (pages 97 through 99, and 100), the tiny *Shelterbelt* (page 101), the two *Sage Angus* works (pages 121, 122), many of the paintings from two late 1980s trips to Africa (pages 103, 114), *January Angus* (page 112), the stunning *Monet's Sheep* (page 119), and several portraits (see pages 109 and 120) —embody the full maturation of his technical skills and the growing intensity of his understanding of and feeling for his subjects. Kirk Robertson earlier mapped this territory well for us, pointing to the surprising and seemingly contradictory intersection in Waddell's paintings of both Monet and Cézanne's strategies for capturing the moment through light and surface, with Abstract Expressionism's distillation of subject and image into fields of raw, unadorned sensation.[24] Robertson recognizes that Waddell's paintings, like Willem de Kooning's and Francis Bacon's before him, deliver a "visceral jolt" of "pure impression, a full draft of the accentuated landscape that is at once itself, yet also an improvised landscape of the imagination." Think back to those drawings Waddell made throughout the 1970s and early '80s, and how firmly they are grounded in the tradition of Constable and Turner, who were fleshing out Burke's and Ruskin's Romantic framings of the artist's work, exploring the smallest parts of the world—sky and cloud, water and light—in order to find those "spiritual facts" in the whole of nature. Ruskin said, "The aim of the great inventive landscape painter must be to give the far higher and deeper truth of mental vision, rather than that of the physical facts . . ."[25] Think, also, of Alfred Stieglitz's photographic cloud studies, the "Equivalents" from the early 1920s and '30s. "I wanted to photograph clouds to find out what I had learned in forty years. . . . [and] through clouds to put down my philosophy of

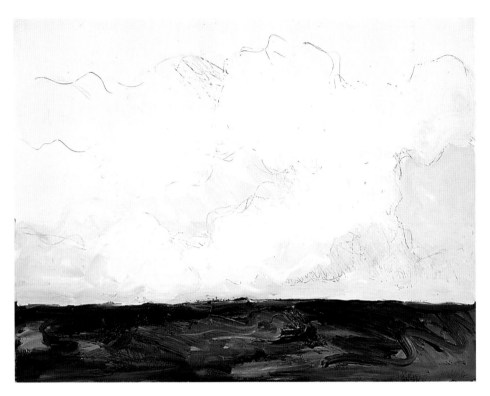

Landscape, Cloud Drawing #7 (1984); oil on paper, 19 ¾ x 25 ¾ in. Collection of the artist.

life."[26] Seeking meaning of the whole through understanding the parts is the desire we hear voiced here. The ground Waddell occupies. And that brings us full circle, back to Cézanne, Monet, right through the American Impressionists, early American photography, Isabelle Johnson, Bill Stockton, and on to Waddell. The modernism Isabelle Johnson and Bill Stockton brought into Montana, no matter how late—Montana is a long ways from anywhere, then and now—from their study of Cézanne, the Postimpressionists, and, later, the Abstract Expressionist trailblazing of Pollock and de Kooning that Waddell absorbed as a graduate student, are all coming together in Waddell's Ryegate paintings.

Waddell is reaching a near complete primacy of the medium over the subject in the paintings of the Ryegate years. Of course the subject leaves a thread, Ariadne-like, for us to follow as we're drawn into the maze of the visual field, but for Waddell it is the work with paint itself, the whole direct physical tradition of the act of painting, that is primary. *Paintings*, someone said, *allow us to receive our own messages, permit us to pursue a conversation with ourselves.* Aesthetic experience is always two-way: the viewer is also offered the chance for change, for seeing and experiencing, along with the artist, the potential for discovering beauty in the utterly commonplace. The paintings ask more questions than they answer, which is all we can expect of art.

The matter of how Waddell's compositions, color strategies, and surfaces relate to those we associate with European Impressionism and American Abstract Expressionist work isn't a small matter here. In

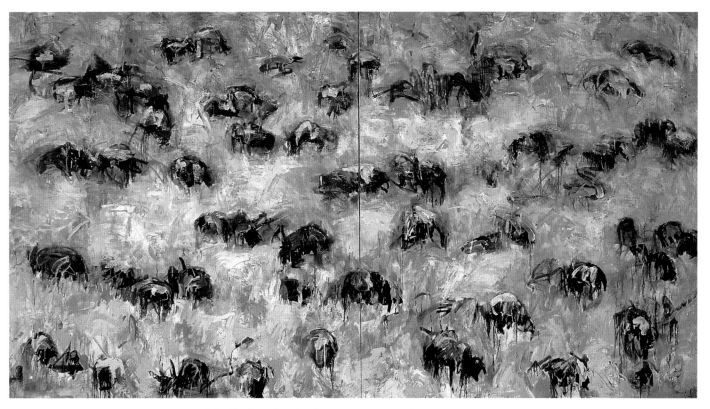

Steinbeck's Sheep (1992); oil on canvas, 84 x 156 in. Collection of the artist.

our urge to find the just the right fit for him in some kind of Aristotelian box, we've been first per-
suaded to invoke Monet—all those swirling colors, the richness of the palette, the obsession with light
and effect—and yet in the next breath are faced with Pollock and de Kooning—the destruction of the
painting's focal center, expansive space, absent edges. The history of American painting is a continu-
ously evolving and complex hybrid of romanticism and realism—neither ever fully goes away, leastways
the romanticism. Waddell recognizes this balance: "My work refers to abstraction in part, and I have
found that the more abstract it becomes, the more real it is." He has been intent on finding a style that
could incorporate loose, unstructured swirls, globs, and smears, masses of rich and lucent colors, along
with random calligraphic lines, as a way of getting at both the physical structure of the landscape and a
record of the experience of place. He has been intensely investigating, experimenting, exploring, and
testing himself against the materials and the rigors and the demands of perception. The collision he
understands, of "abstract" and "real," strongly hints at the way his work meanders, like mature streams
do, between the shores of romanticism and realism. And yet, what movement in art has been more fun-
damentally "romantic" than Abstract Expressionism, with its adherents' belief in the primacy of percep-
tion, the loneliness of the solitary painter wresting from experience the subjectless picture as a record of
pure aesthetic and imaginative power? His muscular brushwork, and the evanescent transparency of the
pigment, encaustic, and layers of varnishes comprise the mysterious visual physics that helps him find a
way not toward any literal transcription of nature, but a full and honest *impression* of a place.

JOSEPH HENRY SHARP (1859–1953), *Untitled* (n.d.);
oil on canvas, 19½ x 23½ in. Yellowstone Art Museum
Permanent Collection, Gift of Virginia Snook.

As a way of finding some footing here, I find a crossroads of Waddell's methods and the spirit he brings to his painting with American Impressionism that intrigues me. Though Isabelle Johnson and Bill Stockton led him, by example, through the early lessons of Cézanne and the Postimpressionists, Waddell seems nonetheless more authentically grounded, finally, in the visual vocabularies of Joseph Henry Sharp, Childe Hassam, William Keith, John Henry Twachtman, and others of the American Impressionists, that generation of painters who immediately followed the Hudson River School. There are, for instance, remarkable congruencies between Twachtman's *Waterfall in Yellowstone* (ca. 1895) and Waddell's several small *Yellowstone Series* paintings. Twachtman thrust the horizon line far up toward the top edge of the painting in order to give

more attention to the land and natural forms themselves. Strong, elemental shapes of trees, cliffs, falls, and the river nearly dissolve into full abstraction. The busy, fluid, but mighty powerful brushwork is mimetic of the place itself: the force of falling water, the turbulent geologic history written in the deep rock gorge. Twachtman, like Waddell, offers us a feeling of immensity, of humbling natural force, of elemental presence. And a strong whiff of the sublime is here, too, as the American Impressionists' inheritance from the Hudson River painters, but without the precious transparency of pigment and the pure light-worshipping that underpins so much of the earlier painters' methods and goals. Waddell admittedly puts the paint down and moves it around with Pollock's intensity, but he is still grounded in the place itself, committed to finding his way into the pure and personal sensation of landscape. His brushwork and the geometric solidity of the landforms—his heritage from the sculpture days—seek after the *character* of place itself. Echoing Cézanne and Twachtman—and the best of Remington when he wasn't spinning

JOHN HENRY TWACHTMAN (1853–1902), *Waterfall in Yellowstone* (ca. 1895); oil on canvas, 25⅜ x 16½ in. Buffalo Bill Historical Center, Cody, Wyoming, Gift of Mr. and Mrs. Cornelius Vanderbilt Whitney. 22.69

FREDERIC REMINGTON (1861–1909), *Untitled
(Impressionistic Fall Scene)*, n.d.; oil on board, 16 x 12⅛ in.
Buffalo Bill Historical Center, Cody, Wyoming, Gift of the
Coe Foundation. 76.67

western myths—more intimately than he does Pollock and de Kooning, Waddell seeks answers to what he calls the "wonderful mysteries that surround me," and so his paintings stand as a continuation and evocation of the power of American Impressionism and yet independently set up and maintain their own view of the world.

> Every continent has its own great spirit of place. Every people is polarized in some particular locality, which is home, the homeland. Different places on the face of the earth have different vital effluence, different vibration, different chemical exhalation, different polarity with different stars: call it what you like, but the spirit of place is a great reality.[27]

The paintings from the Ryegate years are a full record of Waddell's ongoing and deepening exploration of a way to get at the expressiveness—the voice—of place, and of his continuing struggle to simply paint what is there: the extraordinary and sometimes terrible manifestations of nature. That "great reality" has fully become Waddell's essential subject.

> A leaf, a drop, a crystal, a moment of time is related to the
> whole, and partakes of the perfection of the whole. Each particle
> is a microcosm, and faithfully renders the likeness of the world.
>
> EMERSON

In 1995 Waddell entered a difficult period. He separated from his wife that year, exhausted himself with nearly thirty-five gallery shows, and had some health problems. Late that year he left the Musselshell for good, and moved to the Gallatin Valley west of Bozeman. Over the next several years he taught a number of times at Idaho's Sun Valley Art Center, and there he met the writer and photographer Lynn

Campion. They have since married, and now divide their time between central Montana and northern Idaho. Through it all, though, he continued painting, creating during this period the exceptional *Russian John* series (pages 124 to 126), the striking and compelling *Ennis Mare* (page 127), and *Motherwell's Angus #6* (page 123), among many others.

Carrying forward the move he made in the late 1970s from drawing to painting, when he required a change in scale, the works from 1995 to the present reveal that scale, the horizon, and problems of pictorial space are the absorbing and enduring strengths of his painting. For over forty years now, the presence and treatment of the horizon line has helped ground him, helped him find his own place, both his location within the landscape he's worked, and his place painting that land. His continued experiments with scale—note the extraordinary difference in size between the two *Sage Angus* paintings (pages 121 and 122)—allow him the latitude to bring to the paintings mysterious, enveloping sensations, a sense of quietness, and an extension of visual reach. Today, he no longer works closely with livestock, no longer runs fence in the dead of winter, pulls calves night after night in the cold barns. So in the most recent paintings, he is moving farther and farther back from the animals, from any aspect of foreground. The newest paintings, like the monumental *Monida Angus, Yellowstone Horses,* and his most ambitious and important painting to date, *Montana* (pages 134, 135), are about another territory. Immeasurably expressive, these newest works are documents of his desire to know more, to understand fully both the limits of his chosen materials and his own potential.

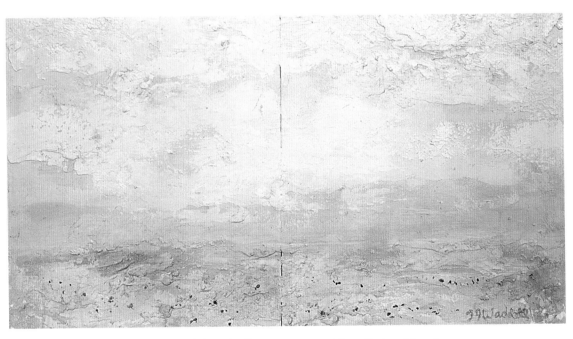

Dry Creek Reds (2000); oil on canvas, 20 x 36 in. Collection of the artist.

In the end, Waddell's newest paintings—freely, spontaneously brushed, with a palette that is lightening and becoming more luminous—convey more abundantly than any before now the transformative effects of habitation, geology, weather, place. His vision contains the abstracted strata of terrain, of emotion, and of perception—consciousness itself. In the hunt for the sensual in landscape, the sensual in the elemental, he gives us the chance to experience these places in a new way, as descriptions and metaphors of beauty, yes, but also of the contrast between an inaccessible *beyond* and the private universe of the artist's experience. With an abundant visual vocabulary of line and mark-making, an acute apprehension of color, and with ferocious intimacy and passion, he is bringing news back to us about a land and an essence we risk forgetting. These paintings ask us what it is we must learn from a place to inhabit it— to know it—fully. For like Eliot before him,[28] Ted Waddell has known that

> *We shall not cease from exploration*
> *And the end of all our exploring*
> *Will be to arrive where we started*
> *And know the place for the first time.*

NOTES

1. Ralph Waldo Emerson, *Nature /* Henry David Thoreau, *Walking*, edited and with an introduction by John Elder. Boston: Beacon Press, 1991, page 8. The Emerson quote here, and all subsequent quotes that appear as section heads, are from Emerson's extended essay, *Nature*, first published in 1836, and Thoreau's 1862 essay *Walking*. The writer Annie Dillard has said, "Emerson's wild metaphysic still underlies American nature writing and still caps American thinking about nature." It is impossible to quibble with Dillard's observation, save that she could have added, following "nature writing," American painting, music, and dance.

2. This quote, and all that follow throughout the text, unless otherwise noted, is drawn from hours of conversations between the artist and the writer between the early fall and late winter of 2000, as well as from transcripts of conversations between the artist and Kirk Robertson, and the artist's writings and statements over several decades, some of which were earlier published in *Theodore Waddell: Seasons of Change*, Indianapolis, IN: Eitlejorg Museum of American Indian and Western Art, 1992.

3. In Alfred Kazin, *A Writer's America*, New York: Alfred A. Knopf, 1988, page 63.

4. Terry Melton, *Paintings: Isabelle Johnson*, Billings, MT: Yellowstone Art Center, 1971, unpaginated.

5. Though Isabelle Johnson is certainly the earliest and most important Montana artist to work in the European modernist traditions—no matter that she came late to these aesthetics—it bears mentioning that her younger peer, the Grass Range sheep rancher Bill Stockton, who studied in Paris and at the Minneapolis Institute of Art, was also working in this vein. For background on other Montana artists courageously working against the dominant Western narratives in the years before the 1950s, including Helen McAuslin, Peter Meloy, Frances Senska, and others, see H. G. Merriam's *The Arts in Montana*, Missoula, MT: Mountain Press 1977.

6. Donna Forbes, *Isabelle Johnson: A Life's Work*, Billings, MT: Yellowstone Art Center, 1992, unpaginated.

7. Isabelle Johnson, in an unpublished interview for a television program with Terry Melton, ca. 1979.

8. Forbes, *Isabelle Johnson: A Life's Work*.

9. Isabelle Johnson, Melton interview.

10. The Archie Bray Foundation, set just west of Helena near the Continental Divide, is Montana's preeminent cultural institution. From its earliest days, the Bray has attracted the world's major ceramicists for residencies and teaching. By way of honoring the Bray's fiftieth anniversary in 2001, the Holter Museum of Art in Helena is mounting a major exhibition of works made at the Bray, and publishing a catalogue with the University of Washington Press.

11. Jonathan Raban, *Bad Land*, New York: Pantheon, 1996, page 51.

12. Barbara Novak, *Nature and Culture: American Landscape and Painting, 1825–75*, London: Oxford University Press, 1980, page 78. For my money, there is no better academic—yet refreshingly readable—study of American Romanticism and its roots in both eighteenth- and nineteenth-century English and Continental philosophy and art than Barbara Novak's. Though others have sketched out the importance, first of Edmund Burke's 1756 *Philosophical Enquiry into the Origins of Our Ideas of the Sublime and Beautiful*, and later John Ruskin's multivolume *Modern Painters* (1851–60) on Constable, Turner, and others, and the way these aesthetic arguments were picked up by American philosophers, critics, and painters, no other writer does so with such thoroughness and verve. Sadly, as I write this, *Nature and Culture* is out of print.

13. Novak, *Nature and Culture*, page 14.

14. Organized by the Corcoran's associate curator for contemporary art, Clair List, in conjunction with the Santa Fe–based Western States Arts Foundation, the exhibition included a number of artists who have gone on to significant careers, including David Bates, Joan Brown, John Buck, and Gaylen Hanson, among others.

15. Grace Glueck, "Two Biennials: One Looking East and the Other West," *New York Times* March 27, 1983, page 35; and Paul Richard, "The Range of the West," *Washington Post* February 2, 1983, page D1.

16. Mark Stevens, "Art Under the Big Sky," *Newsweek* October 31, 1983, pp. 98–100.

17. Richard, "The Range of the West," *Washington Post*, page D1.

18. Lee Fleming, "The Corcoran Biennial/Second Western States Exhibition," *ARTnews*, May 1983, pp. 127–129.

19. Henry David Thoreau, *Journals,* New York: Dover, 1961, page 164.

20. Gordon McConnell, *Theodore Waddell,* Billings, MT: Yellowstone Art Center, 1984, unpaginated. See also McConnell's "Country Flesh and Bones," *Artspace: Southwestern Contemporary Arts Quarterly* (7):3, Summer 1983, pages 22–23; and *The Montana Collection,* Billings, MT: Yellowstone Art Museum, 1998, pages 46–50. McConnell, Curator at the Yellowstone Art Center from 1982 to 1998, has written well and persuasively about Waddell's work for over fifteen years. No one knows his work better. A painter himself, McConnell concentrates more intensively on Waddell's technical approaches and methods.

21. Isabelle Johnson, Melton interview.

22. For a thorough discussion of these origins, see Simon Schama, *Landscape and Memory*, New York: Alfred A. Knopf, 1975, pages 10–19. Perhaps the most complete study of the origins of the European landscape tradition is Christopher S. Wood's *Albrecht Altdorfer and the Origins of Landscape*, Chicago: University of Chicago Press, 1993.

23. See the discussion of Ruskin in Novak, *Nature and Culture.*

24. It bears mentioning here Michael Leja's essay, "The Monet Revival and New York School Abstraction," in Paul Hays Tucker's *Monet in the 20th Century*, London and New York: Royal Academy of Arts, London, and Museum of Fine Arts, Boston, pub-lished in association with Yale University Press, 1998. In his essay, Leja explores the seams where Monet's late, and mostly abstract, paintings intersect with mid-century Abstract Expressionism and Abstract Impressionism.

25. Quoted in Joni Louise Kinsey, *Thomas Moran and the Surveying of the American West*, Washington DC: Smithsonian Institution Press, 1992, page 14.

26. Quoted in Beaumont Newhall, *The History of Photography*, New York: Museum of Modern Art, 1964, page 113. First published in *Amateur Photographer*, September 19, 1923, page 255.

27. D. H. Lawrence, "The Spirit of Place," in Kinsey, *Thomas Moran,* page 1.

28. T. S. Eliot, "Little Gidding," in *Four Quartets,* New York: Harcourt Brace Jovanovich, 1993, 1971, page 240.

SELECTED BIBLIOGRAPHY

Ashton, Dore, *The New York School: A Cultural Reckoning.* New York: Viking Press, 1972.

Bennett, Steve, "Death and Dying: New Perspectives," *San Antonio Light,* May 28, 1987, p. F13.

Broder, Patricia, *The American West: The Modern Vision.* Boston: New York Graphic Society Books, published by Little, Brown & Co., 1984.

Bruce, Chris, *Myth of the West.* New York: Rizzoli International Publications, in association with the Henry Art Gallery, University of Washington, 1990.

Daniels, Stephen, *Fields of Vision: Landscape Imagery and National Identity in England and the United States.* Princeton, NJ: Princeton University Press, 1993.

Doig, Ivan, *This House of Sky: Landscapes of a Western Mind.* New York: Harcourt, Brace and Company, 1978.

Emerson, Ralph Waldo, *Nature* / Henry David Thoreau, *Walking,* ed. John Elder. Boston: Beacon Press, 1991.

Ewing, Robert, "Enduring Romantic Idioms," *Artweek* June 2, 1984, p. 3.

Fleming, Lee, "The Corcoran Biennial/Second Western States Exhibition," *ARTnews* May 1983, pp. 127–29.

Forbes, Donna, *Isabelle Johnson: A Life's Work.* Billings, MT: Yellowstone Art Center, 1992.

Forbes, Donna, and Terry Melton, Bill Stockton, and Ted Waddell, *Isabelle Johnson: A Retrospective.* Billings, MT: Yellowstone Art Center, 1986.

Friedman, Martin L., and others, *Visions of America: Landscape as Metaphor in the Late Twentieth Century.* Denver, CO: Denver Art Museum; and Columbus, OH: Columbus Museum of Art, distributed by Harry N. Abrams, 1994.

Goetzmann, William H., and William N. Goetzmann, *The West of the Imagination.* New York: W. W. Norton, 1986.

Glueck, Grace. "Two Biennials: One Looking East and the Other West." *The New York Times,* March 27, 1983, p. 35.

Goddard, Dan L., "Waddell Gives Twist to Western Myth," *San Antonio Sunday Express-News,* May 31, 1987, p. 7H.

Gussow, Alan, *A Sense of Place—The Artist and the American Land.* Washington, DC: Island Press, 1997.

Hassrick, Peter, and others, *The American West: Out of Myth, Into Reality.* Washington, DC: Trust for Museum Exhibitions in association with the Mississippi Museum of Art, 2000.

Kazin, Alfred, *A Writer's America: Landscape in Literature.* New York: Alfred A. Knopf, 1988.

Kinsey, Joni Louise, *Thomas Moran and the Surveying of the American West*. Washington, DC: Smithsonian Institution Press, 1992.

Leja, Michael, *Reframing Abstract Expressionism: Subjectivity and Paintings in the 1940s*. New Haven, CT: Yale University Press, 1993.

————"The Monet Revival and New York School Abstraction," in *Monet in the 20th Century*, London and New York: Royal Academy of Arts, London, and Museum of Fine Arts, Boston, 1998, pp. 98–108.

Limerick, Patricia Nelson, *The Legacy of Conquest: The Unbroken Past of the American West*. New York: W. W. Norton, 1987.

———— *Something in the Soil: Legacies and Reckonings in the New West*. New York: W. W. Norton, 2000.

Mannheimer, Steve, "Waddell's Paintings Present a Primal Home on the Range," *The Indianapolis Star*, February 7, 1993, Section G, p. 6.

McConnell, Gordon, *The Montana Collection*. Billings, MT: Yellowstone Art Museum, 1998.

———— "Ted Waddell: Country Flesh and Bones," *Artspace*, Summer 1983, pp. 22–23.

———— *Theodore Waddell*. Billings, MT: Yellowstone Art Center, 1984.

Melton, Terry, *Paintings: Isabelle Johnson*. Billings, MT: Yellowstone Art Center, 1971.

Merriam, H. G., ed., *The Arts in Montana*. Missoula, MT: Mountain Press, 1977.

Morch, Al, "A Cattleman's Down-to-Earth Montana Art," *San Francisco Examiner*, January 9, 1984, p. C10.

Newhall, Beaumont, *The History of Photography: From 1863 to the Present*. New York: Museum of Modern Art in association with the New York Graphic Society, 1964.

Nochlin, Linda, *Impressionism and Post-Impressionism 1874–1904*. Englewood Cliffs, NJ: Prentice-Hall, 1966.

Novak, Barbara, *Nature and Culture: American Landscape and Painting, 1825–75*. London: Oxford University Press, 1980.

Pincus, Robert L., "With a Peaceful Pallette, Montana Artist Lights Up Big Sky," *San Diego Union-Tribune*, February 16, 1995, p. 47.

Polcari, Stephen, *Abstract Expressionism and the Modern Experience*. Cambridge, England: Cambridge University Press, 1991.

Raban, Jonathan, *Bad Land: An American Romance*. New York: Pantheon Books, 1996.

———— "Battleground of the Eye," *Atlantic Monthly*, March 2001, pp. 40–52.

Richard, Paul, "The Range of the West," *The Washington Post*, February 2, 1983, p. D1.

Rosenblum, Robert, *Modern Painting and the Northern Romantic Tradition: Friedrich to Rothko*. New York: Harper and Row, 1975.

Rosenthal, Mark, *Abstraction in the Twentieth Century: Total Risk, Freedom, Discipline*. New York: Guggenheim Museum Publications, in association with Harry N. Abrams, 1996.

Sandler, Irving, *The Triumph of American Painting: A History of Abstract Expressionism.* New York: Praeger, 1970.

Schama, Simon, *Landscape and Memory.* New York: Alfred A. Knopf, 1975.

Shepard, Odell, ed., *The Heart of Thoreau's Journals.* New York: Dover Publications, 1961.

Smith, Henry Nash, *Virgin Land: The American West as Symbol and Myth.* Cambridge, MA: Harvard University Press, 1970.

Stevens, Mark, "Art Under the Big Sky," *Newsweek,* October 31, 1983, pp. 98–100.

Stewart, Marilyn, "The Essence of Place in the Work of Ted Waddell," *SchoolArts,* November 1997, p. 25.

Troccoli, Joan Carpenter, *Painters and the American West: The Anschutz Collection.* Denver, CO: Denver Art Museum; New Haven, CT: Yale University Press, 2000.

Tucker, Paul Hayes, George Shackelford, and MaryAnne Stevens, *Monet in the 20th Century.* London and New York: Royal Academy of Arts, London, and Museum of Fine Arts, Boston. Published in association with Yale University Press, 1998.

Turner, David G., *Theodore Waddell: Seasons of Change.* Indianapolis, IN: Eiteljorg Museum of American Indian and Western Art, 1992.

White, Richard, *It's Your Misfortune and None of My Own: A New History of the American West.* Norman, OK: University of Oklahoma Press, 1991.

Wilkins, Thurman, *Thomas Moran: Artist of the Mountains.* Norman, OK: University of Oklahoma Press, 1998.

Wood, Christopher S., *Albrecht Altdorfer and the Origins of Landscape.* Chicago: University of Chicago Press, 1993.

PORTFOLIO

Head of a Man (1963); oil on canvas, 8 x 10 in.
Collection of the artist.

Head of a Man #2 (1963); oil on canvas, 8 x 10 in.
Collection of the artist.

P. 15 (1966); oil on canvas, 32 x 27¼ in. Collection of the artist.

P. 16 (X One) (1966); oil on canvas, 28½ x 24¼ in.
Collection of the artist.

P. 5 (Black, White, Gray) (1966); oil on canvas, 48½ x 36 in.
Collection of the artist.

Quadrant (1969); stainless steel; 24½ in. square.
Yellowstone Art Museum Permanent Collection,
Gift of Terry Melton.

Untitled (1969); stainless and painted steel,
16 dia. x 3 in. Collection of the artist.

Untitled (1969); stainless steel, 13½ x 14 x 12 in.
Collection of the artist.

Untitled (1969–70); stainless steel, 31 x 58 x ½ in.
Collection of the artist.

Untitled (1970); stainless steel, 7⅛ x 16½ x 3⅛ in.
Collection of Janelle Stephens.

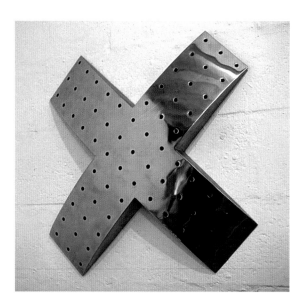

Untitled (1972); stainless steel, 23¼ x 23¼ x 2½ in.
Collection of Shanna Shelby.

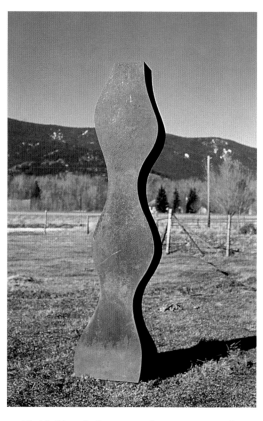

Untitled (1971); Cor-ten steel, 120 x 25 x 23¼ in.
Collection of the artist.

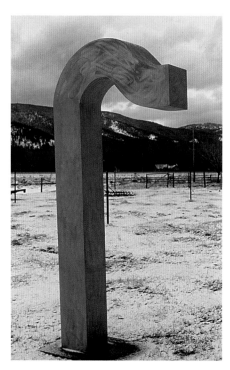

Untitled (1972); stainless steel,
102 x 47 x 12 in. Collection of the artist.

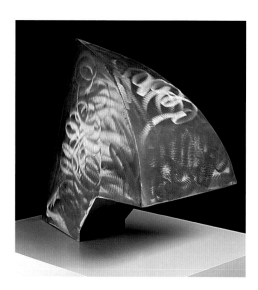

Untitled (1975); stainless steel, 23 x 16 x 24 in.
Collection of Arin Waddell.

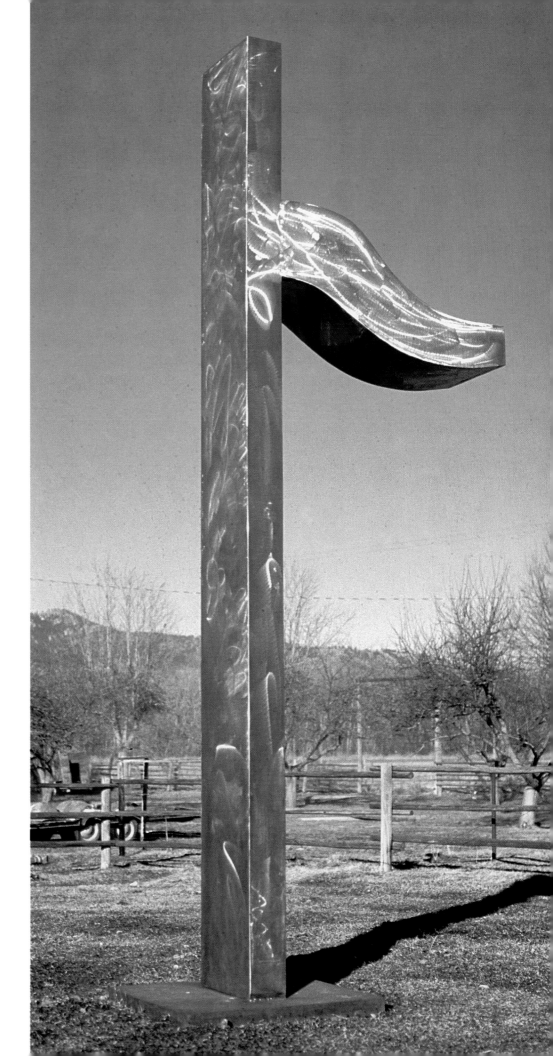

Untitled (1972); stainless steel,
144 x 47 x 18 in.
Collection of the artist.

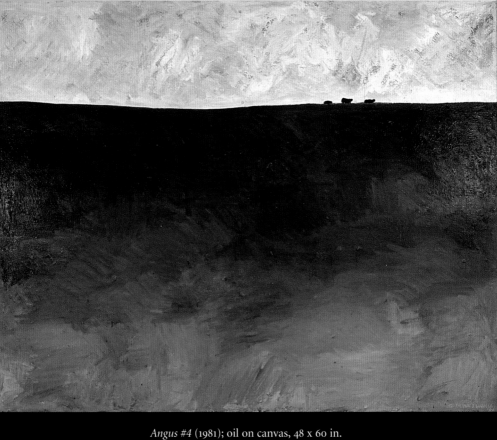

Angus #4 (1981); oil on canvas, 48 x 60 in.
Yellowstone Art Museum Permanent Collection, Gift of Miriam Sample.

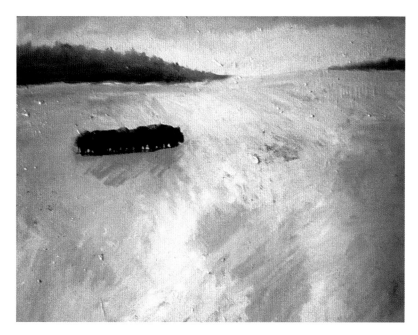

Angus #11 (1981); oil and enamel on canvas, 36 x 48 in.
Collection of Donna Forbes.

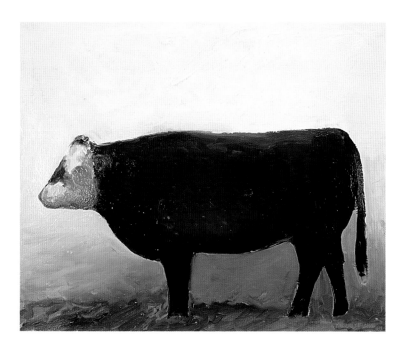

Angus #15 (Miss America) (1981); oil on canvas, 30 x 36 in.
Collection of the artist.

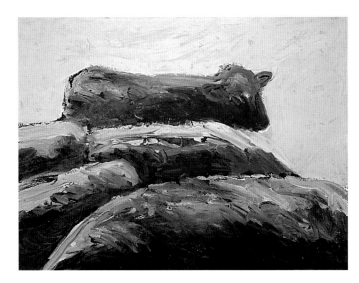

Angus #21 (1982); oil on canvas, 36 x 48 in. Collection of the artist.

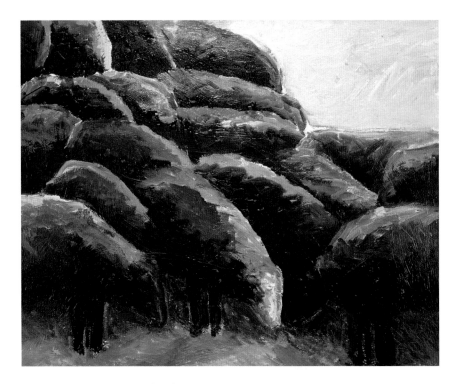

Augus #23 (1982); oil on canvas, 48 x 60 in. Collection of the artist.

right: *Augus #23.* (detail)

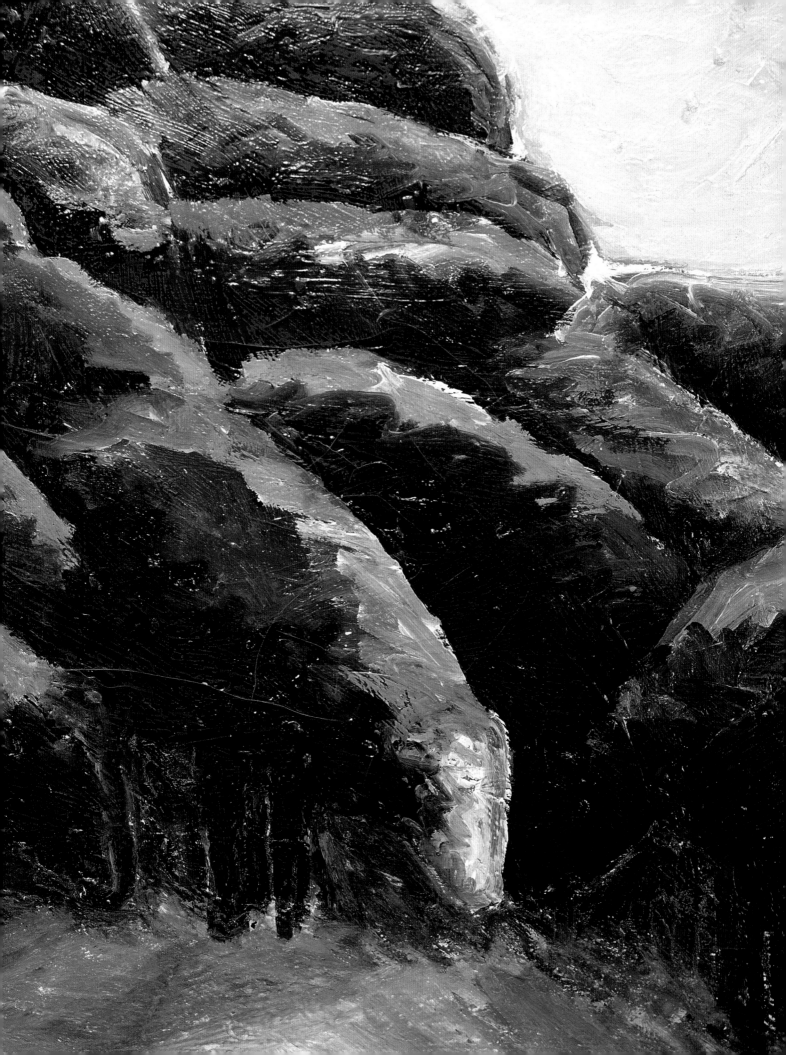

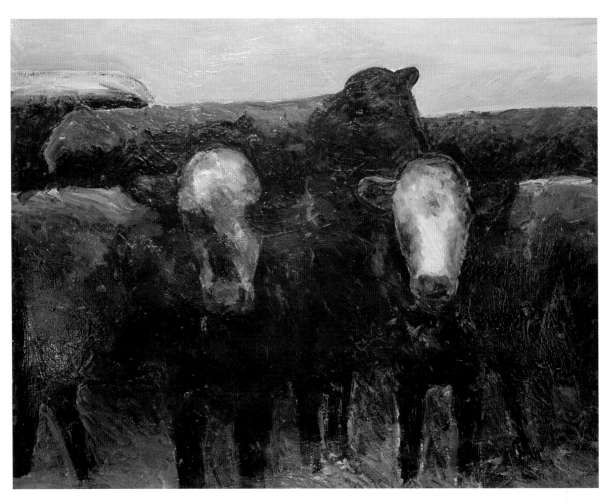

Angus #24 (1982); oil on canvas, 48 x 60 in. Collection of the artist.

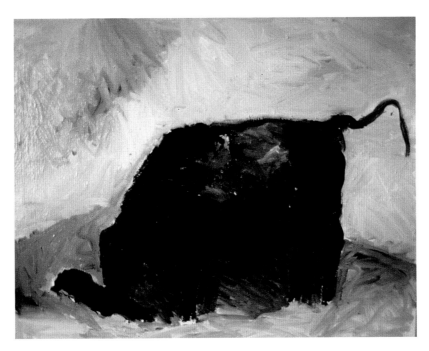

Cow and Calf (1982); oil on canvas, 48 x 60 in.
Collection of Betty Whiting.

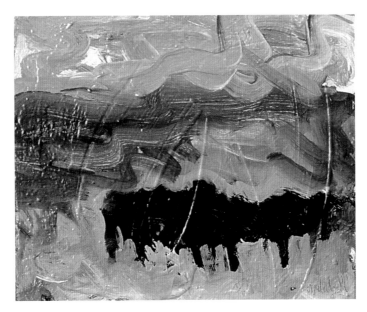

Angus #54 (1982); oil on canvas, 9½ x 11½ in.
Collection of Lynn Campion.

Coyote #1 (1982); mixed media on canvas, 48 x 72 in. Collection of the artist.

Trophy #3 (1982); cow skull and mixed media, 19 x 13½ x 19½ in. Collection of the artist.

Trophy #5 (1983); cow skull and mixed media; 16 x 19½ x 19½ in. Collection of the artist.

Trophy #8 (1983); cow skull and mixed media, 15¼ x 19 x 28½ in.
Collection of Brian Peterson.

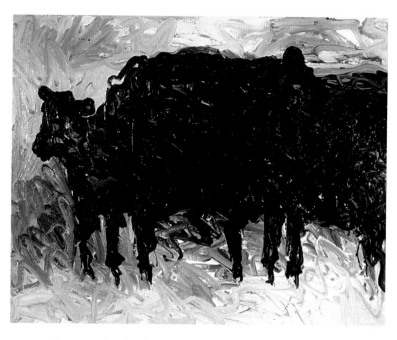

Angus #65 (1983); oil on canvas, 48 x 60 in. Collection of the artist.

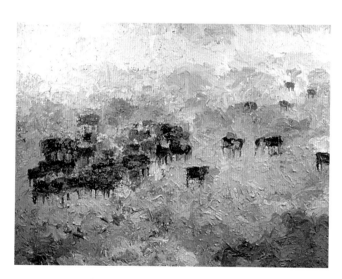

Angus #116 (1984); oil on canvas, 60 x 78 in.
Yellowstone Art Museum Permanent Collection.

Longhorn #8 (1983); oil on canvas, 36 x 48 in.
Collection of the artist.

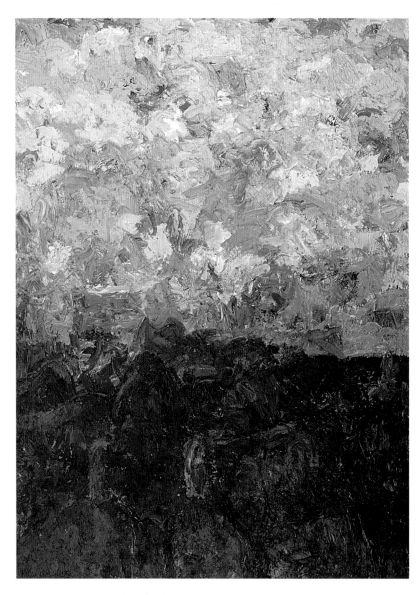

Angus #115A (1985); oil on canvas, 90 x 66 in. Collection of the artist.

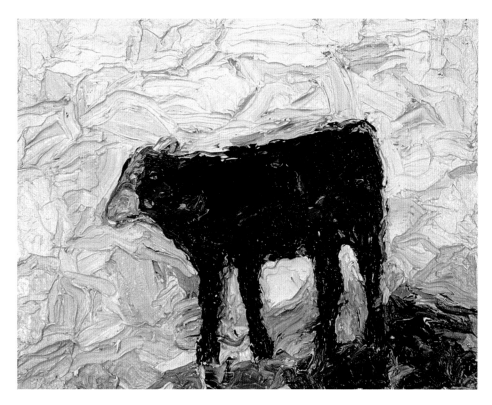

Angus #134 (1986); oil on canvas, 24 x 30 in. Collection of Betty Whiting.

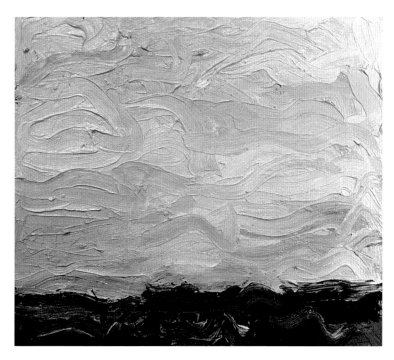

Cloud Landscape #3 (1985); oil on canvas, 20 x 18 in. Collection of the artist.

Angus #135 (1986); oil on canvas, 12 x 10 in. Collection of Brian Peterson.

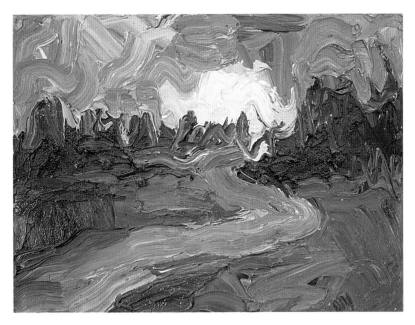

Yellowstone Park Series, Firehole River (1987); oil on canvas, 18 x 24 in.
Collection of the artist.

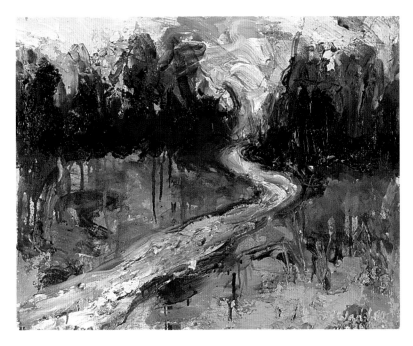

Yellowstone Park Series, Firehole River #2 (1987); oil on canvas, 18 x 24 in.
Collection of Les and Peggy Frank.

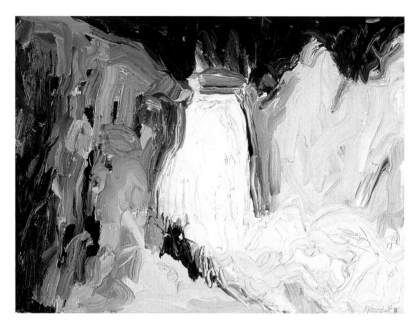

Yellowstone Park Series, Yellowstone Falls #1 (1987); oil on canvas, 18 x 24 in.
Collection of Betty Whiting.

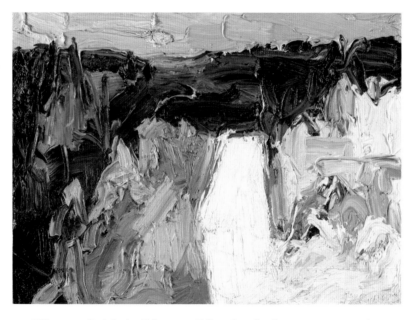

Yellowstone Park Series, Yellowstone Falls #3 (1987); oil on canvas, 18 x 24 in.
Collection of Les and Peggy Frank.

right: *Yellowstone Park Series, Yellowstone Falls #3.* (detail)

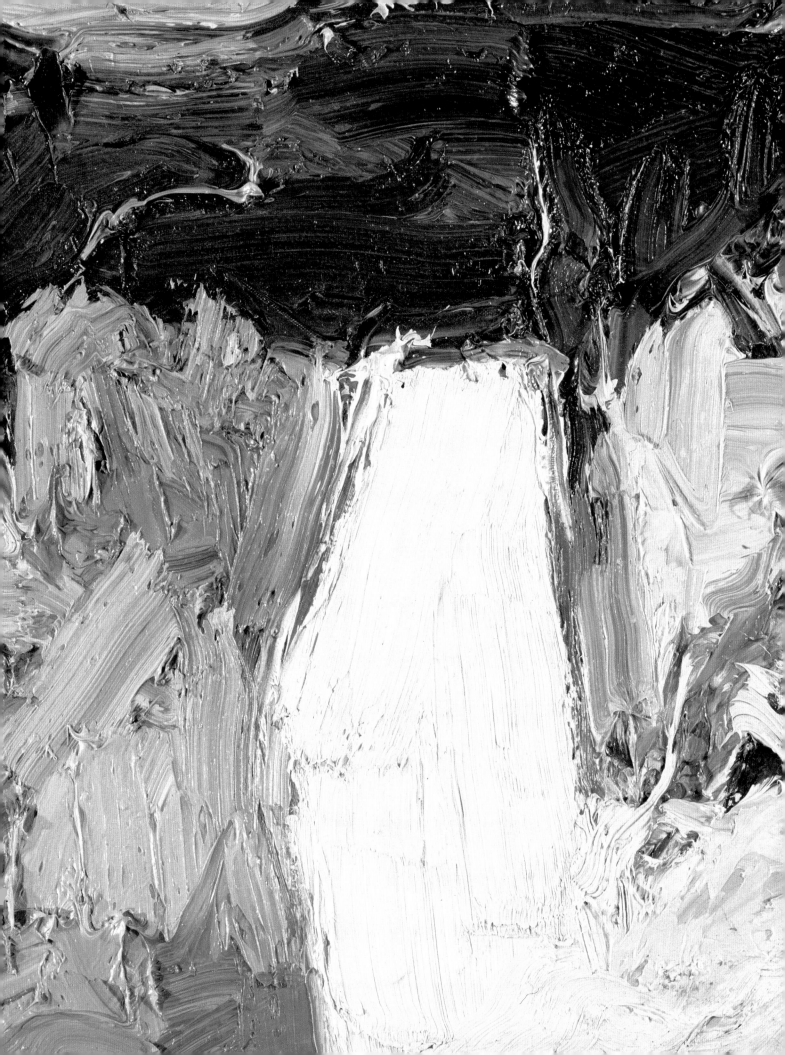

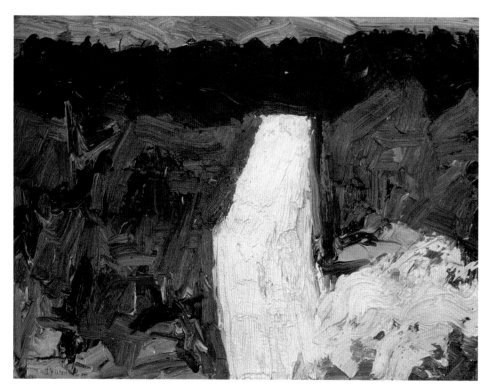

Yellowstone Park Series, Yellowstone Falls #4 (1987); oil on canvas, 18 x 24 in.
Collection of the artist.

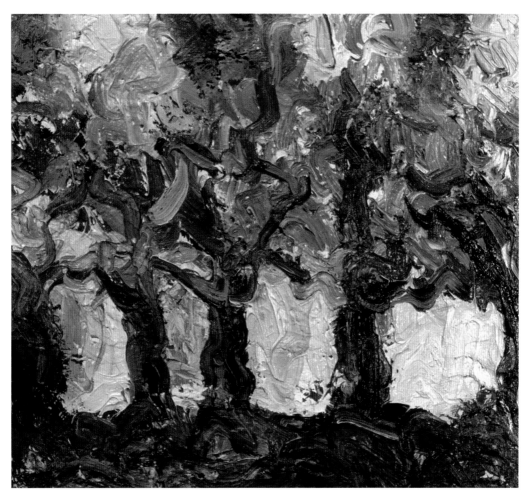

Shelterbelt (1988); oil on canvas, 18 x 20 in.
Collection of Betty Whiting.

Writer Trophy (1988); mixed media, 35 x 21½ x 18 in.
Collection of Arin Waddell.

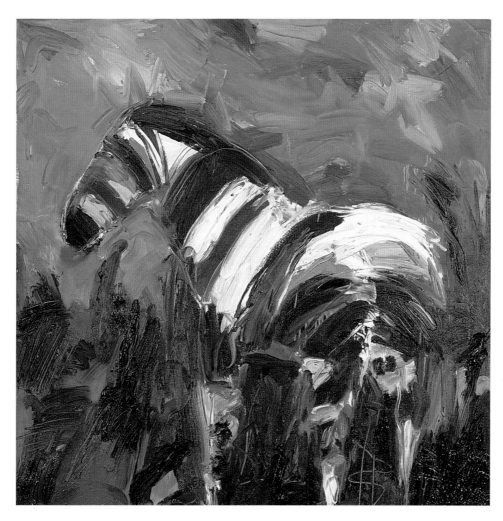

Zebra #14 (1988); oil on canvas, 36 x 36 in. Collection of the artist.

Tumbleweed Ladder (1988); tumbleweed and plastic, 3¾ x 24 x 73½ in.
Collection of the artist.

Dry Land Trout (1988); wood, straw, and fiberglass, 55 x 18 x 6 in.
Collection of the artist.

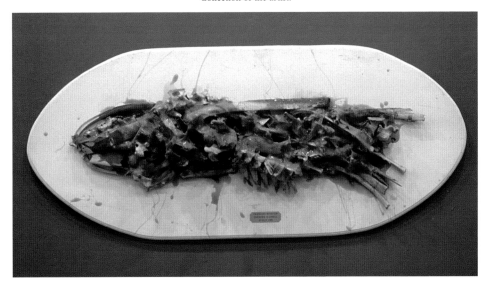

Chatham's Bonefish (1989); mixed media, 19 x 45 x 4 in. Collection of the artist.

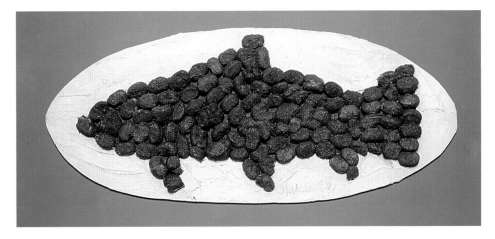

Horse Shit Trout (1989); mixed media, 19 x 48 in. Collection of the artist.

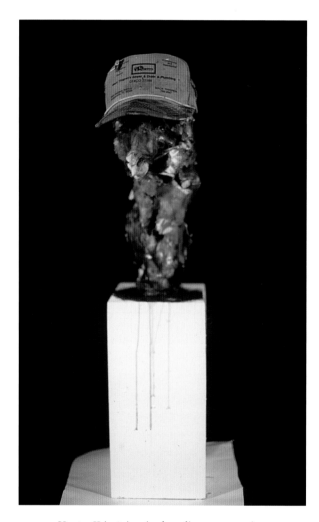

Hunter II (1989); mixed media, 33 x 7 x 13 in.
Collection of Betty Whiting.

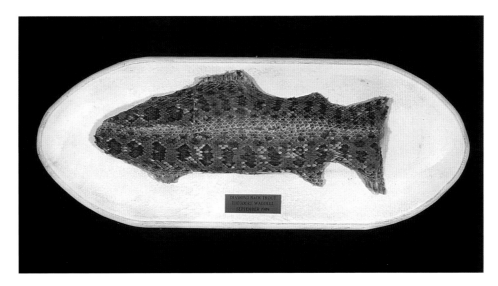

Diamond Back Trout (1989); mixed media, 9 x 24 x 4 in. Collection of the artist.

Sagebrush Trout (1989); mixed media, 19 x 55 x 4 in. Collection of the artist.

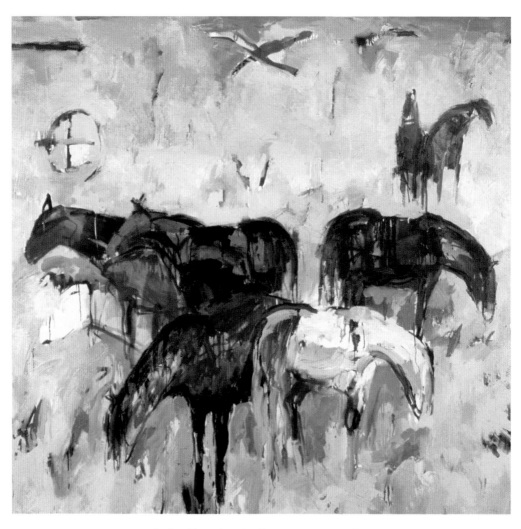

Lavina Horses (1990); oil on canvas, 70 x 72 in.
Yellowstone Art Museum Permanent Collection,
Museum purchase with funds provided by Miriam Sample.

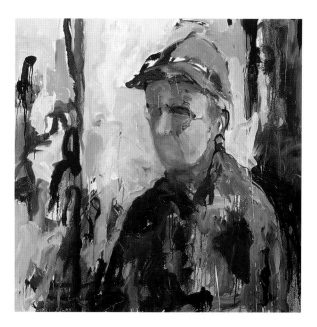

Walt (1990); oil on canvas, 42 x 40 in. Collection of the artist.

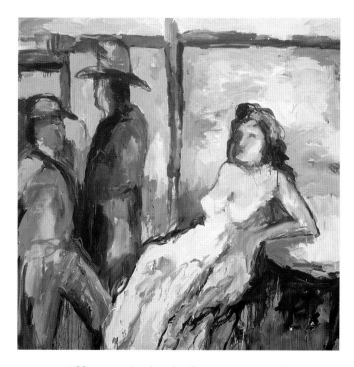

Wedding Reception (1990); oil on canvas, 72 x 72 in.
Collection of the artist.

Anderson Deer (1991); mixed media, 12 x 32 x 21 in.
Collection of the artist.

King Deer (1991); mixed media, 19 x 29 x 35 in.
Collection of the artist.

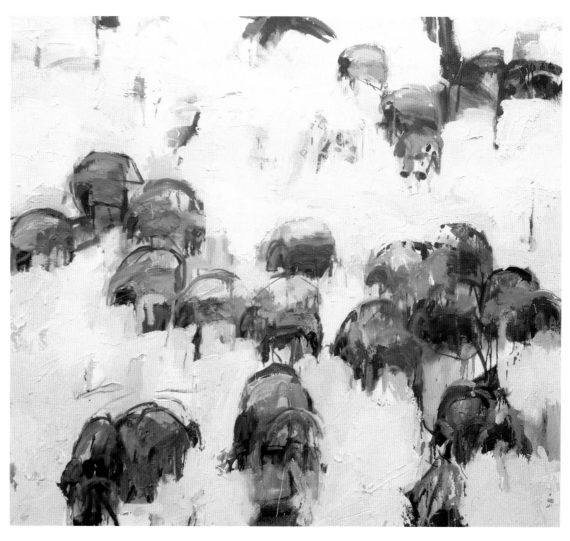

Basin Sheep #2 (1991); oil on canvas, 64 x 60 in. Collection of the artist.

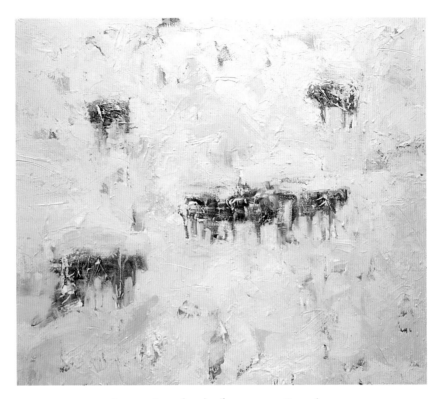

January Angus (1991); oil on canvas, 48 x 42 in.
Collection of Lynn Campion.

Ghost Cow (1992); cow skull and mixed media, 30 x 29 x 14 in.
Collection of the artist.

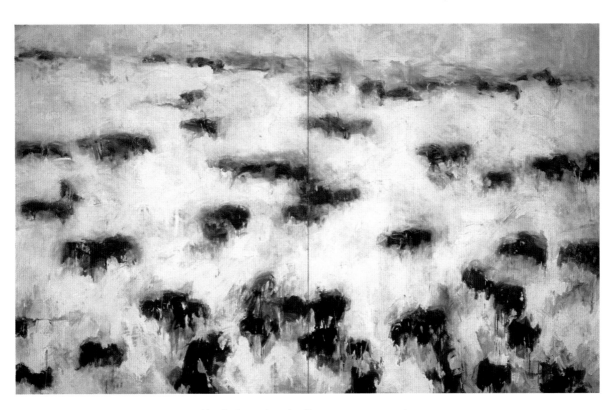

Alzada Angus (1992); oil on canvas, 72 x 144 in.
Yellowstone Art Museum Permanent Collection, Museum purchase funded by Miriam Sample.

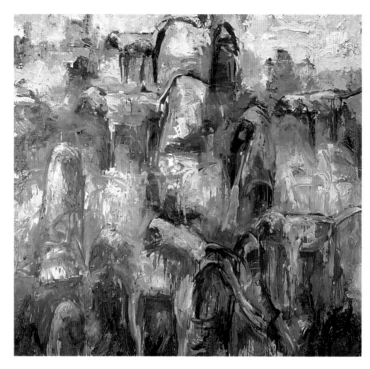

Botswana Baboons (1992); oil on canvas, 72 x 72 in.
Yellowstone Art Museum Permanent Collection, Gift of Betty Whiting.

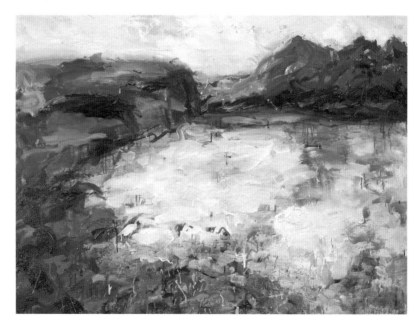

Streek's Landing (1992); oil on canvas, 36 x 48 in.
Collection of Jack and Sally Dern.

right: *Streek's Landing.* (detail)

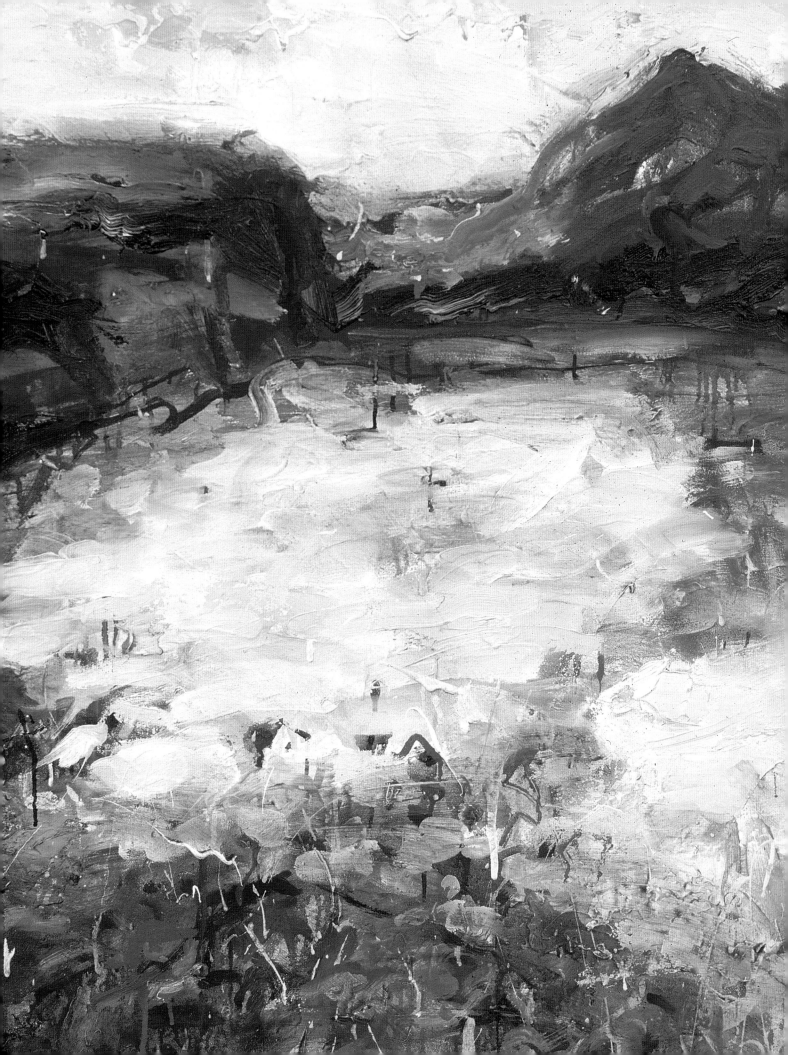

Bone Handled .45 (1992); mixed media, 5 x 10 x 16 in.
Collection of the artist.

Pearl Handle .45 (1992); mixed media, 5 x 10 x 16 in.
Collection of the artist.

R. 45 (1992); mixed media, 5 x 11 x 17 in. Collection of the artist.

Snake Charmer (1992); mixed media, 5½ x 33 in. Collection of the artist.

Goodall Family Chronicle (1993); oil on canvas, 78 x 90 in.
Collection of Dr. and Mrs. William Goodall.

Body Bag for a Whitetail Deer (1994); mixed media, 47 x 59¼ in.
Collection of the artist.

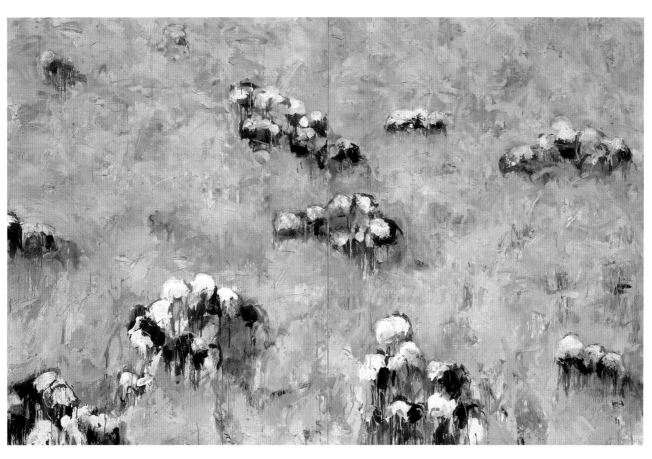

Monet's Sheep (1994); oil and encaustic on canvas, 78 x 120 in.
Collection of John W. and Carol L. H. Green.

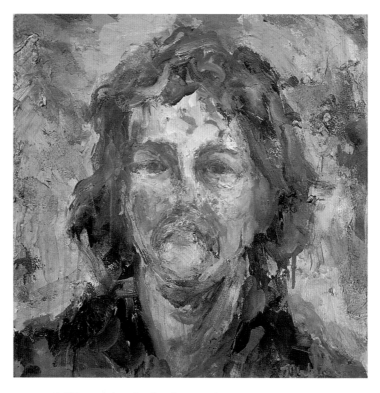

Self Portrait (1994); oil and encaustic on canvas, 20 x 20 in.
Collection of the artist.

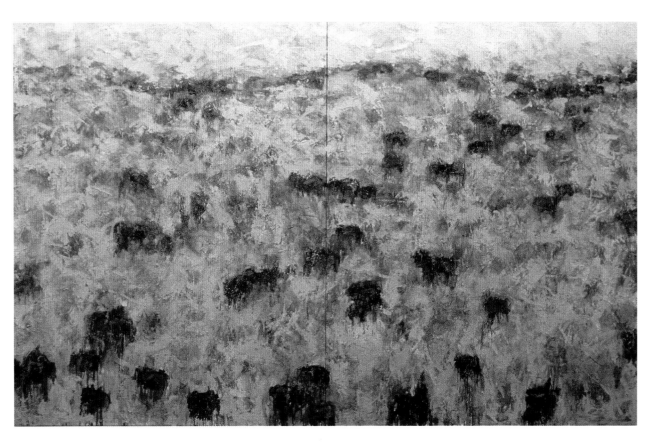

Sage Angus (1994); oil and encaustic on canvas, 90 x 144 in. Collection of the artist.

Body Bag for a Raccoon (1994); mixed media, 23 x 47 in.
Collection of John Heyneman.

Sage Angus #5 (1995); oil and encaustic on canvas, 8 x 10 in.
Collection of the artist.

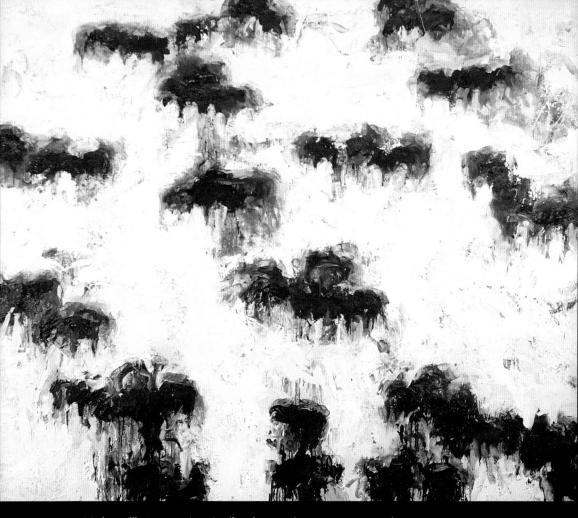

Motherwell's Angus #6 (1996); oil and encaustic on canvas, 66 x 78 in. Collection of the artist.

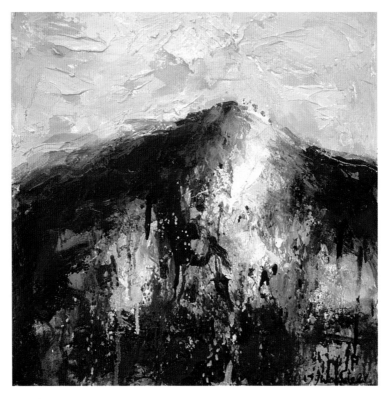

Russian John (1996); oil and encaustic on canvas, 16 x 16 in.
Collection of the artist.

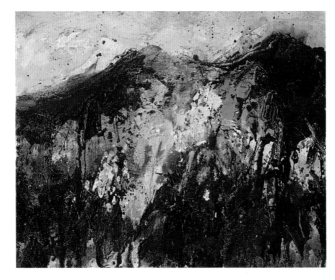

Russian John #2 (1996); oil and encaustic on canvas, 16 x 16 in.
Collection of the artist.

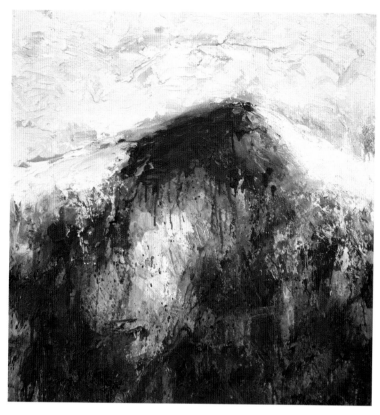

Russian John #3 (1996); oil and encaustic on canvas, 30 x 32 in.
Collection of the artist.

Russian John #4 (1996); oil and encaustic on canvas, 8 x 8 in.
Collection of the artist.

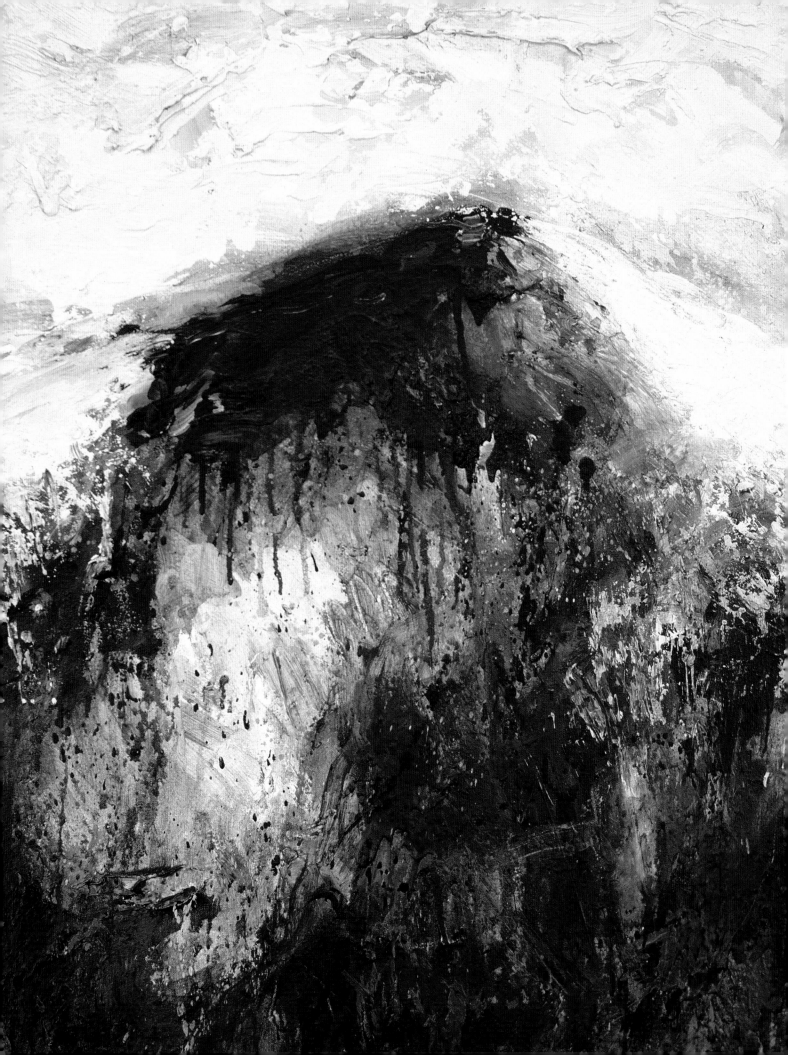

Yellowstone Park Series, Firehole River #2 (1998); oil on canvas, 18 x 24 in.
Collection of the artist.

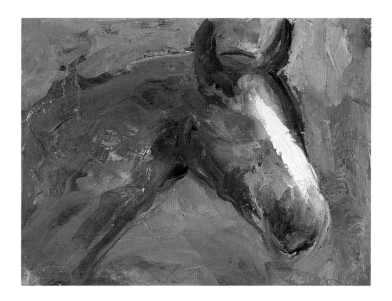

Ennis Mare (1997); oil and encaustic on canvas, 18 x 24 in.
Collection of William Bliss.

left: *Russian John #3.* (detail)

.38 Cal. Derringer (1999); mixed media, 2⅞ x 8⅞ x 6¾ in.
Collection of the artist.

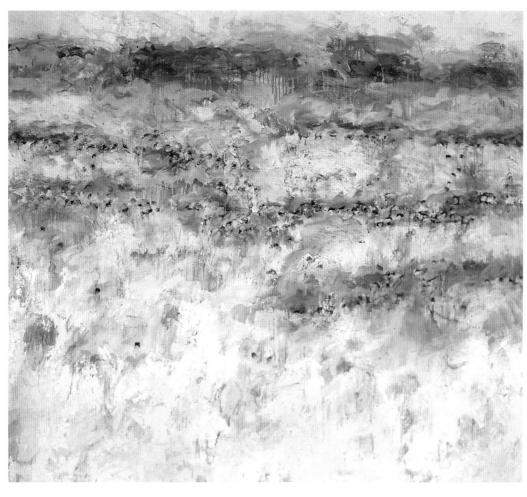

Monida Angus (1999); oil and encaustic on canvas, 88 x 144 in.
Collection of the artist.

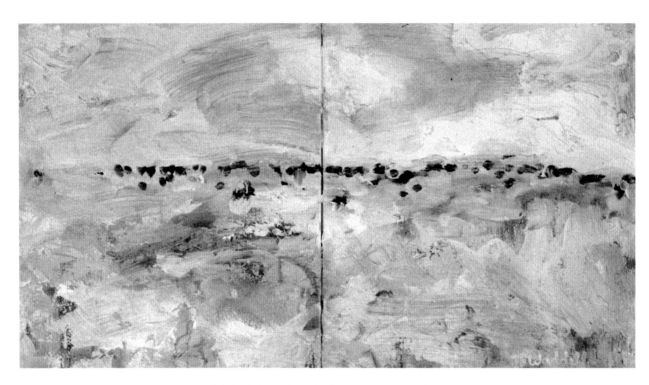

Iris Creek Angus (1999); oil on canvas, 20 x 36 in.
Collection of the artist.

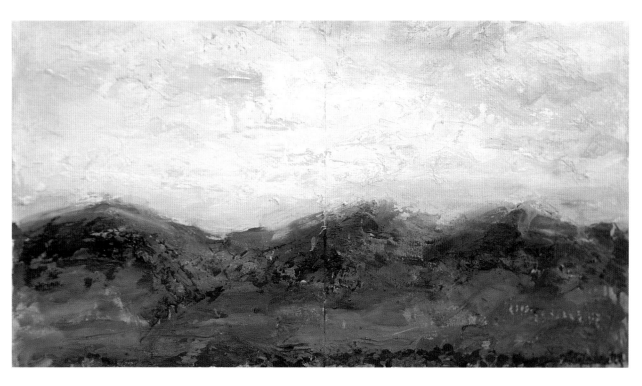

Ross Peak Angus #2 (2000); oil and encaustic on canvas, 20 x 36 in.
Collection of the artist.

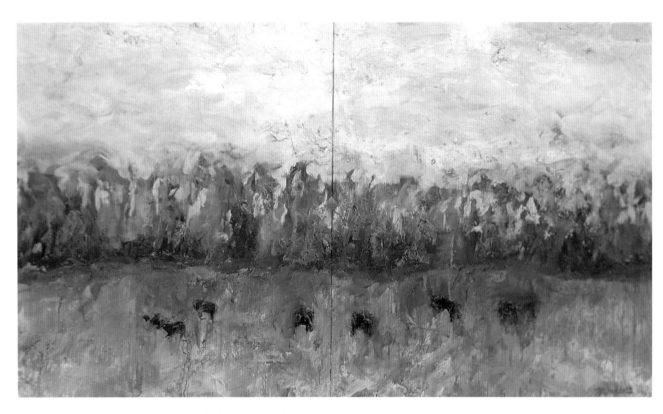

Yadon's Angus (2000); oil and encaustic on canvas, 40 x 72 in.
Collection of the artist.

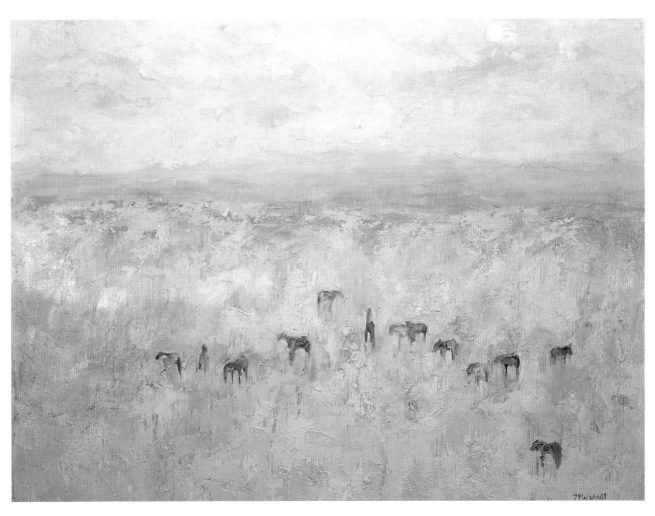

Yellowstone Horses (2000); oil on canvas, 72 x 96 in. Collection of the artist.

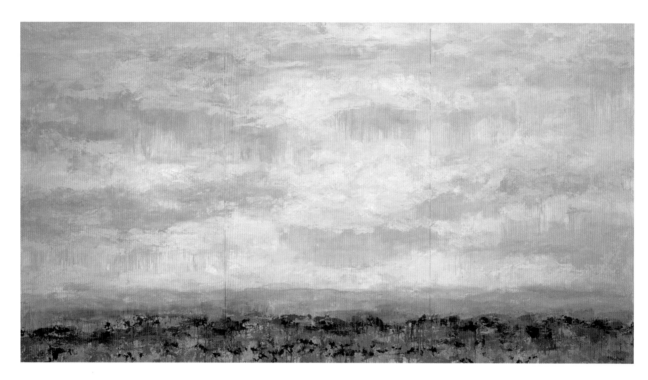

Montana (2000); oil on canvas, 120 x 216 in. Collection of the artist.

right: *Montana.* (detail)

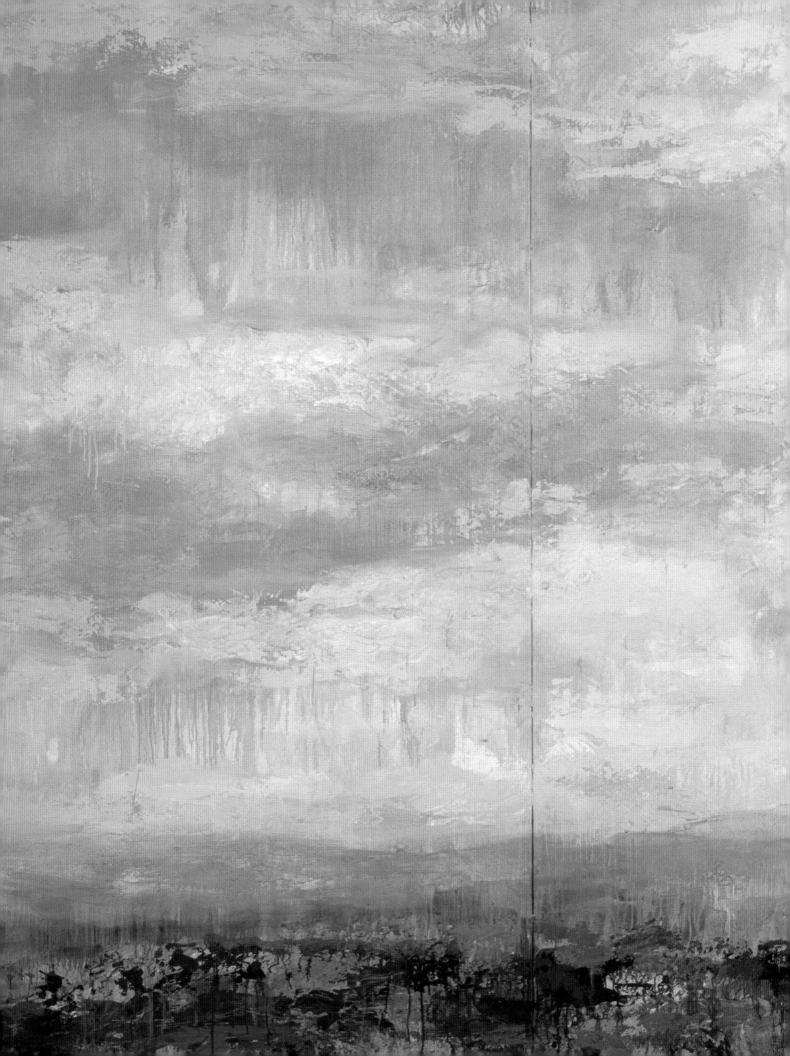

EXHIBITION CHECKLIST

Head of a Man (1963)
Oil on canvas
8 x 10 in.
Collection of the artist

Head of a Man #2 (1963)
Oil on canvas
8 x 10 in.
Collection of the artist

P. 15 (1966)
Oil on canvas
32 x 27¼ in.
Collection of the artist

P. 16 (X One) (1966)
Oil on canvas
28½ x 24¼ in.
Collection of the artist

P. 5 (Black, White, Gray) (1966)
Oil on canvas
48½ x 36 in.
Collection of the artist

Untitled (1969)
Stainless and painted steel
16 dia. x 3 in.
Collection of the artist

Quadrant (1969)
Stainless steel
24½ in. square
Accession #1998.003
Yellowstone Art Museum
Permanent Collection
Gift of Terry Melton

Untitled (1969)
Stainless steel
13½ x 14 x 12 in.
Collection of the artist
Yellowstone Art Museum only

Untitled (1969–70)
Stainless steel
31 x 58 x ½ in.
Collection of the artist

Untitled (1970)
Stainless steel
7⅛ x 16½ x 3⅛ in.
Collection of Janelle Stephens

Untitled (1971)
Cor-ten steel
120 x 25 x 23¼ in.
Collection of the artist
Yellowstone Art Museum only

Untitled (1972)
Stainless steel
23¼ x 23¼ x 2½ in.
Collection of Shanna Shelby

Untitled (1972)
Stainless steel
144 x 47 x 18 in.
Collection of the artist
Yellowstone Art Museum only

Untitled (1972)
Stainless steel
102 x 47 x 12 in.
Collection of the artist
Yellowstone Art Museum only

Untitled (1975)
Stainless steel
23 x 16 x 24 in.
Collection of Arin Waddell

Angus #4 (1981)
Oil on canvas
48 x 60 in.
Accession #1998.001
Yellowstone Art Museum
Permanent Collection
Gift of Miriam Sample

Angus #11 (1981)
Oil and enamel on canvas
36 x 48 in.
Collection of Donna Forbes
Yellowstone Art Museum only

Angus #15 (Miss America) (1981)
Oil on canvas
30 x 36 in.
Collection of the artist

Angus #21 (1982)
Oil on canvas
36 x 48 in.
Collection of the artist

Augus #23 (1982)
Oil on canvas
48 x 60 in.
Collection of the artist

Angus #24 (1982)
Oil on canvas
48 x 60 in.
Collection of the artist

Angus #54 (1982)
Oil on canvas
9½ x 11½ in.
Collection of Lynn Campion
Yellowstone Art Museum only

Cow and Calf (1982)
Oil on canvas
48 x 60 in.
Collection of Betty Whiting
Yellowstone Art Museum only

Coyote #1 (1982)
Mixed media on canvas
48 x 72 in.
Collection of the artist
Yellowstone Art Museum only

Trophy #3 (1982)
Cow skull and mixed media
19 x 13½ x 19½ in.
Collection of the artist
Yellowstone Art Museum only

Trophy #5 (1983)
Cow skull and mixed media
16 x 19½ x 19½ in.
Collection of the artist
Yellowstone Art Museum only

Trophy #8 (1983)
Cow skull and mixed media
15¼ x 19 x 28½ in.
Collection of Brian Peterson
Yellowstone Art Museum only

Longhorn #8 (1983)
Oil on canvas
36 x 48 in.
Collection of the artist
Yellowstone Art Museum only

Angus #65 (1983)
Oil on canvas
48 x 60 in.
Collection of the artist
Yellowstone Art Museum only

Angus #116 (1984)
Oil on canvas
60 x 78 in.
Accession #1985.013
Yellowstone Art Museum
Permanent Collection

Angus #115A (1985)
Oil on canvas
90 x 66 in.
Collection of the artist
Yellowstone Art Museum only

Cloud Landscape #3 (1985)
Oil on canvas
20 x 18 in.
Collection of the artist

Angus #134 (1986)
Oil on canvas
24 x 30 in.
Collection of Betty Whiting
Yellowstone Art Museum only

Angus #135 (1986)
Oil on canvas
12 x 10 in.
Collection of Brian Peterson
Yellowstone Art Museum only

*Yellowstone Park Series,
Firehole River* (1987)
Oil on canvas
18 x 24 in.
Collection of the artist

*Yellowstone Park Series,
Yellowstone Falls #1* (1987)
Oil on canvas
18 x 24 in.
Collection of Betty Whiting

*Yellowstone Park Series,
Firehole River #2* (1987)
Oil on canvas
18 x 24 in.
Collection of Les and Peggy Frank

*Yellowstone Park Series,
Yellowstone Falls #3* (1987)
Oil on canvas
18 x 24 in.
Collection of Les and Peggy Frank

*Yellowstone Park Series,
Yellowstone Falls #4* (1987)
Oil on canvas
18 x 24 in.
Collection of the artist

Shelterbelt (1988)
Oil on canvas
18 x 20 in.
Collection of Betty Whiting
Yellowstone Art Museum only

Writer Trophy (1988)
Mixed media
35 x 21½ x 18 in.
Collection of Arin Waddell
Yellowstone Art Museum only

Zebra #14 (1988)
Oil on canvas
36 x 36 in.
Collection of the artist

Tumbleweed Ladder (1988)
Tumbleweed and plastic
3¾ x 24 x 73½ in.
Collection of the artist
Yellowstone Art Museum only

Dry Land Trout (1988)
Wood, straw, and fiberglass
55 x 18 x 6 in.
Collection of the artist
Yellowstone Art Museum only

Chatham's Bonefish (1989)
Mixed media
19 x 45 x 4 in.
Collection of the artist
Yellowstone Art Museum only

Horse Shit Trout (1989)
Mixed media
19 x 48 in.
Collection of the artist
Yellowstone Art Museum only

Hunter II (1989)
Mixed media
33 x 7 x 13 in.
Collection of Betty Whiting
Yellowstone Art Museum only

Sagebrush Trout (1989)
Mixed media
19 x 55 x 4 in.
Collection of the artist
Yellowstone Art Museum only

Diamond Back Trout (1989)
Mixed media
9 x 24 x 4 in.
Collection of the artist
Yellowstone Art Museum only

Lavina Horses (1990)
Oil on canvas
70 x 72 in.
Accession #1991.006
Yellowstone Art Museum
Permanent Collection
Museum purchase with funds
provided by Miriam Sample

Walt (1990)
Oil on canvas
42 x 40 in.
Collection of the artist

Wedding Reception (1990)
Oil on canvas
72 x 72 in.
Collection of the artist

Anderson Deer (1991)
Mixed media
12 x 32 x 21 in.
Collection of the artist

King Deer (1991)
Mixed media
19 x 29 x 35 in.
Collection of the artist

Basin Sheep #2 (1991)
Oil on canvas
64 x 60 in.
Collection of the artist

January Angus (1991)
Oil on canvas
48 x 42 in.
Collection of Lynn Campion
Yellowstone Art Museum only

Ghost Cow (1992)
Cow skull and mixed media
30 x 29 x 14 in.
Collection of the artist

Alzada Angus (1992)
Oil on canvas
72 x 144 in.
Accession #1994.002
Yellowstone Art Museum
Permanent Collection
Museum purchase funded by
Miriam Sample

Botswana Baboons (1992)
Oil on canvas
72 x 72 in.
Accession #1997.009
Yellowstone Art Museum
Permanent Collection
Gift of Betty Whiting
Yellowstone Art Museum only

Streek's Landing (1992)
Oil on canvas
36 x 48 in.
Collection of Jack and Sally Dern
Yellowstone Art Museum only

Bone Handled .45 (1992)
Mixed media
5 x 10 x 16 in.
Collection of the artist

Pearl Handle .45 (1992)
Mixed media
5 x 10 x 16 in.
Collection of the artist

R. 45 (1992)
Mixed media
5 x 11 x 17 in.
Collection of the artist

Snake Charmer (1992)
Mixed media
5½ x 33 in.
Collection of the artist

Goodall Family Chronicle (1993)
Oil on canvas
78 x 90 in.
Collection of Dr. and Mrs.
William Goodall

Body Bag for a Whitetail Deer (1994)
Mixed media
47 x 59¼ in.
Collection of the artist

Monet's Sheep (1994)
Oil and encaustic on canvas
78 x 120 in.
Collection of John W. and
Carol L. H. Green
Yellowstone Art Museum only

Sage Angus (1994)
Oil and encaustic on canvas
90 x 144 in.
Collection of the artist

Self Portrait (1994)
Oil and encaustic on canvas
20 x 20 in.
Collection of the artist

Body Bag for a Raccoon (1994)
Mixed media
23 x 47 in.
Collection of John Heyneman

Sage Angus #5 (1995)
Oil and encaustic on canvas
8 x 10 in.
Collection of the artist
Yellowstone Art Museum only

Motherwell's Angus #6 (1996)
Oil and encaustic on canvas
66 x 78 in.
Collection of the artist

Russian John (1996)
Oil and encaustic on canvas
16 x 16 in.
Collection of the artist

Russian John #2 (1996)
Oil and encaustic on canvas
16 x 16 in.
Collection of the artist

Russian John #3 (1996)
Oil and encaustic on canvas
30 x 32 in.
Collection of the artist

Russian John #4 (1996)
Oil and encaustic on canvas
8 x 8 in.
Collection of the artist

Ennis Mare (1997)
Oil and encaustic on canvas
18 x 24 in.
Collection of William W. Bliss

*Yellowstone Park Series,
Firehole River #2* (1998)
Oil on canvas
18 x 24 in.
Collection of the artist

Monida Angus (1999)
Oil and encaustic on canvas
88 x 144 in.
Collection of the artist

.38 Cal. Derringer (1999)
Mixed media
2⅞ x 8⅞ x 6¾ in.
Collection of the artist

Iris Creek Angus (1999)
Oil on canvas
20 x 36 in.
Collection of the artist
Yellowstone Art Museum only

Ross Peak Angus #2 (2000)
Oil and encaustic on canvas
20 x 36 in.
Collection of the artist
Yellowstone Art Museum only

Yadon's Angus (2000)
Oil and encaustic on canvas
40 x 72 in.
Collection of the artist
Yellowstone Art Museum only

Yellowstone Horses (2000)
Oil on canvas
72 x 96 in.
Collection of the artist

Montana (2000)
Oil on canvas
120 x 216 in.
Collection of the artist

SELECTED EXHIBITIONS

2001 Museum of the Southwest, Midland, Texas

2000 *Printmaking Survey,* University of North Dakota, Fargo, North Dakota
 Theodore Waddell: A Retrospective, 1960–2000, Yellowstone Art Museum, Billings, Montana

1999 Dennos Museum Center, Northwestern Michigan College, Traverse City, Michigan
 Holter Museum of Art, Helena, Montana

1998 Sacred Heart University, Center for Contemporary Art, Fairfield, Connecticut
 Paris Gibson Square Museum of Art, Great Falls, Montana
 Yellowstone Art Museum, Billings, Montana
 Eiteljorg Museum, Indianapolis, Indiana
 Cheney Cowles Museum, Spokane, Washington
 University of Wyoming, Laramie, Wyoming

1997 Lone Star Park, Grand Prairie, Texas
 Yellowstone Art Museum, Billings, Montana
 Buffalo Bill Historical Center, Cody, Wyoming
 Paris Gibson Square Museum of Art, Great Falls, Montana
 Missoula Museum of Art, Missoula, Montana

1996 Buffalo Bill Historical Center, Cody, Wyoming
 Prints from the Lawrence Lithography Workshop, Topeka Public Library, Topeka, Kansas
 Cornish College of Art, Seattle, Washington

1995 McAllen International Museum, McAllen, Texas
 Made in L.A.: The Prints of Cirrus Editions, Los Angeles County Museum of Art,
 Los Angeles, California
 Museum of Northwest Art Grand Opening Exhibition, Museum of Northwest Art,
 La Conner, Washington
 Confronting Nature: Silenced Voices, California State University, Fullerton, California, and
 Chapman University, Orange, California
 Festival of Cultures, Rocky Mountain College, Billings, Montana
 Diggs Gallery, Winston-Salem State University, Winston-Salem, North Carolina

1994 Art Museum of South Texas, Corpus Christi, Texas

Holter Museum of Art, Helena, Montana

Nicolaysen Art Museum, Casper, Wyoming

Yellowstone Art Museum, Billings, Montana

Animals: Culturally Constructed, Kohler Art Center, Sheboygan, Wisconsin

Rock Art, Old Main Museum, Northern Arizona University, Flagstaff, Arizona

Town and Country, The Museum of Modern Art, Art Advisory Service for General Electric,
New York City

Missouri River Interpretations: Paintings, Prose, Poems & Prints; traveling exhibition to
Missoula Museum of the Arts, Western Montana College at Dillon; Hockaday Center
for the Arts, Kalispell, Montana; Beall Art Center, Bozeman, Montana; Liberty Village,
Chester, Montana

1993 Eiteljorg Museum, Indianapolis, Indiana

Nevada Museum of Art, Reno, Nevada

North Dakota State University Student Memorial Gallery, Fargo, North Dakota

Missouri River Exhibition, Paris Gibson Square Museum of Art, Great Falls, Montana

Montana Landscapes, Beall Park Art Center, Bozeman, Montana

1992 Stanford Faculty Club, Stanford University, Stanford, California

Horses, Dahl Fine Arts Center, Rapid City, South Dakota

Sculpture: Waddell & Voss, Cheney Cowles Museum, Spokane, Washington

University of Puget Sound School of Law, Tacoma, Washington

1991 *Mystical Reflections of the Big Sky;* Haynes Hall Gallery, Montana State University,
Bozeman, Montana; Holter Museum of Art, Helena, Montana; Custer County
Museum, Miles City, Montana; Hockaday Center for the Arts, Kalispell, Montana;
Western Montana College, Dillon, Montana; and others

Member's Gallery, Albright-Knox Art Gallery, Buffalo, New York

Big Sky/Bold Wind: The Montana Collection of the Yellowstone Art Center, Boulder Art
Center, Boulder, Colorado

Faculty + Faculty, University of Puget Sound, Tacoma, Washington

Experimental Workshop Prints, Richard H. Reynolds Gallery, University of the Pacific Art
Center, Stockton, California

1990 Museum of the Rockies, Bozeman, Montana

Buffalo Bill Historical Center, Cody, Wyoming

Montana 3-D, Hockaday Center for the Arts, Kalispell, Montana

Looking at the Land: The New Art of the West, Eiteljorg Museum, Indianapolis, Indiana

75th Anniversary of Rocky Mountain Park, Boulder Art Center, Boulder, Colorado; and University of Wyoming Art Museum, Laramie, Wyoming

Post Westerns and *Winter Country*, Yellowstone Art Center, Billings, Montana

1989 Art Museum of Southeast Texas, Beaumont, Texas

Nicolaysen Art Museum, Casper, Wyoming

Prints and Multiples from the Experimental Workshop, University of Wisconsin, Milwaukee, Wisconsin

Hockaday Center for the Arts, Kalispell, Montana

Ucross Foundation, Ucross, Wyoming

1988 San Antonio Art Institute, San Antonio, Texas

University of Wyoming, Laramie, Wyoming

Editions from the Experimental Workshop, Redding Museum and Shasta College, Redding, California

Scottsdale Center for the Arts, Scottsdale, Arizona

Art from Montana, Cultural Exchange Exhibition, Tokyo and Kumamoto, Japan

1987 North Dakota Museum of Art, Grand Forks, North Dakota

Northern Arizona University, Flagstaff, Arizona

Missoula Museum of Art, Missoula, Montana

University of Tennessee, Knoxville, Tennessee

Paris Gibson Square Museum of Art, Great Falls, Montana

Montana State University, Bozeman, Montana

Hockaday Center for the Arts, Kalispell, Montana

Montana Collection 1985–87, Yellowstone Art Center, Billings, Montana

American Academy of Arts and Letters, New York City

1986 Paris Gibson Square Museum of Art, Great Falls, Montana

Sun Valley Center, Sun Valley, Idaho

The New West, Colorado Springs Fine Art Gallery, Colorado Springs, Colorado

Hockaday Center for the Arts, Kalispell Montana

Mariana Gallery, University of Northern Colorado, Greeley, Colorado

Georgia Museum of Art, Athens, Georgia

1985 Cheney Cowles Memorial Museum, Spokane, Washington

Selections for the Michener Collection, University of Texas Art Gallery, Ransom Center, Austin, Texas

1984 Hockaday Center for the Arts, Kalispell, Montana

Yellowstone Art Center, Billings, Montana

Invitational Sculpture Show, Custer County Art Center, Miles City, Montana

Long Beach Museum of Art, Long Beach, California; and San Francisco Museum of Modern Art, San Francisco, California

1983 *Second Western States Exhibition and 38th Corcoran Biennial Exhibition of American Painting;* traveling exhibition originated at the Corcoran Gallery of Art, Washington, D.C.

Lakeview Museum of Arts and Sciences, Peoria, Illinois

Scottsdale Center for the Arts, Scottsdale, Arizona

Albuquerque Museum, Albuquerque, New Mexico

1982 Billings Livestock Commission and Longan Galleries, Billings, Montana

1980 Paris Gibson Square Museum of Art, Great Falls, Montana

Yellowstone Art Center, Billings, Montana

1970 Montana State University, Bozeman, Montana

University of Wisconsin – Green Bay, Green Bay, Wisconsin

1969 Yellowstone Art Center, Billings, Montana

C. M. Russell Museum, Great Falls, Montana

1968 Albany Art Gallery, Albany, New York

COLLECTIONS

Apple Computer, Inc., Saratoga, California

Arco Corporation, Los Angeles California; Philadelphia Pennsylvania

Bank of America, San Francisco, California

Buffalo Bill Historical Museum, Cody, Wyoming

Carnation Company, Los Angeles, California

Cheney Cowles Museum, Spokane, Washington

Citadel Corporation, Scottsdale, Arizona

Clorox Corporation, San Francisco, California

Custer County Art Center, Miles City, Montana

Dallas Museum of Art, Dallas, Texas

Denver Art Museum, Denver, Colorado

Eiteljorg Museum, Indianapolis, Indiana

Federal Reserve Bank, Minneapolis Minnesota and Helena, Montana

First Interstate Bank, Las Vegas, Nevada

Frederick R. Weisman Company, Los Angeles, California

Frito-Lay Corporation, Dallas, Texas

Goddard Center for Performing and Visual Arts, Ardmore, Oklahoma

Gonzaga University, Spokane, Washington

Hallmark Art Collection, Kansas City, Missouri

Harrah's Enterprises, Reno, Nevada

Hockaday Art Center, Kalispell, Montana

Holter Museum of Art, Helena, Montana

International Business Machines

Los Angeles County Museum of Art, Los Angeles, California

Marriot Corporation, San Antonio, Texas

Merck Corporation, West Point, Pennsylvania

Michener Collection, Austin, Texas

Missoula Museum of the Arts, Missoula, Montana

Mobil Oil, New York, New York

Nestles Corporation, Los Angeles, California

Nordstrom, Seattle, Washington

North Dakota Museum of Art, Grand Forks, North Dakota

Northern Arizona University, Flagstaff, Arizona

Omaha National Bank, Omaha, Nebraska

Pillsbury Corporation, Minneapolis, Minnesota

Progressive Corporation, Pepper Pike, Ohio

Rayovac Corporation, Madison, Wisconsin

Rocky Mountain College, Billings, Montana

Safeco, Seattle, Washington

San Jose Museum of Art, San Jose, California

Security Pacific Bank, Los Angeles, California

Sheldon Memorial Museum, Lincoln, Nebraska

Sierra Pacific Power, Reno, Nevada

Spencer Museum, Lawrence, Kansas

Stanford University Hospital, Stanford, California

United Airlines, Chicago, Illinois

United Missouri Bank, Kansas City, Missouri

University Hospital, University of Washington, Seattle, Washington

University of New Mexico, Albuquerque, New Mexico

University of North Dakota, Fargo, North Dakota

University of Texas, Austin, Texas

University of Wyoming, Laramie, Wyoming

Yellowstone Art Museum, Billings, Montana

CONTRIBUTORS

PETER H. HASSRICK is Charles Marion Russell Professor of American Western Art and Director of the Charles M. Russell Center for the Study of Art of the American West at the University of Oklahoma in Norman. He was founding director of the Georgia O'Keeffe Museum in Santa Fe, New Mexico, and for twenty years served as director of the Buffalo Bill Historical Center in Cody, Wyoming, following his tenure at the Amon Carter Museum in Fort Worth, Texas. His numerous publications on art and the West include *Treasures of the Old West* (1984), *Charles Russell* (1989), and *Frederic Remington: A Catalogue Raisonné of Paintings, Watercolors and Drawings* (1996), with Melissa Webster.

TERRY MELTON, a painter and writer, lives and works in Salem, Oregon. He has been executive director of the McAllen International Museum, McAllen Texas, the C. M. Russell Museum in Great Falls, Montana, and the Yellowstone Art Museum, as well as vice president of the Western Association of Art Museums and a founding member of the Western States Arts Federation. He has also served as Regional Representative for the National Endowment for the Arts, and has been active in many western arts organizations. He has shown his paintings, prints, and drawings in more than fifty exhibitions.

BEN MITCHELL is a writer and curator. He is the author of *Play Disguised: The Jewelry of Ken Cory*, published by the University of Washington Press in conjunction with the 1997 Tacoma Art Museum exhibition, and *Brad Rude: Original Nature*, published by the Holter Museum of Art, Helena, Montana, in 1998. He is Senior Curator at the Yellowstone Art Museum.

KIRK ROBERTSON is a poet, writer, and visual artist who has lived in Fallon, Nevada, since 1976. His *Music: A Suite and Thirteen Songs,* and *Just Past Labor Day: Selected & New Poems, 1969-1995,* the two most recent of his many books of poetry, were published by Floating Island in 1995 and the University of Nevada Press in 1996. He is the editor of *neon, Artcetera,* the Journal of the Nevada Arts Council, and writes about art and artists for a number of periodicals. A collection of these essays is forthcoming.